CW01391671

MORE BUTCH HEROES

MORE BUTCH HEROES

Ria Brodell

foreword by Chris E. Vargas
with S. E. Fleenor

The MIT Press
Cambridge, Massachusetts
London, England

The MIT Press would like to thank the anonymous peer reviewers who provided comments on drafts of this book. The generous work of academic experts is essential for establishing the authority and quality of our publications. We acknowledge with gratitude the contributions of these otherwise uncredited readers.

This book was set in Garamond Premier Pro by the MIT Press. Printed and bound in the United States of America.

Library of Congress Cataloging-in-Publication Data is available.

ISBN: 978-0-262-04987-0

10 9 8 7 6 5 4 3 2 1

To our future

Contents

Foreword

Our Butchcestors: Navigating Trans and Nonbinary Histories
with Ria Brodell's *Butch Heroes*

I had the privilege to become acquainted with Ria Brodell's *Butch Heroes* series when I organized a show in 2015 at the Henry Art Gallery, the museum connected to the University of Washington in Seattle. This show was part of a decade-long project I'd been working on called the Museum of Trans Hirstory & Art, or MOTHA. MOTHA is a conceptual, forever-under-construction institution that highlights trans art and culture while also casting a critical eye at the history of the museum with its white, colonial, cis-hetero-patriarchal roots. I am this, mostly immaterial, institution's self-appointed Executive Director. The show itself was part of MOTHA's exhibition series "Trans Hirstory in 99 Objects," and that particular iteration at the Henry focused on trans hirstories of the greater Pacific Northwest. With the support and advice of curator Nina Bozicnik we exhibited two works by Brodell, *Sitting in the Water Grizzly, c. 1780s–1837 Ktunaxa Nation* (2011) and *Jeanne or Jean Bonnet, 1849–1876 United States* (2012). These works introduced viewers, respectively, to a prophetic Indigenous figure with a magical story in both life and death and a Parisian-born San Francisco transplant who caught and sold frogs to restaurants and stirred up lots of trouble, for fun and for their own livelihood. About eight years after that show, I was honored to publish Brodell's depiction and text connected to the latter figure, *Jeanne or Jean Bonnet*, in the MOTHA volume *Trans Hirstory in 99 Objects* (2023), an extension of that initial exhibition project in book form.

A concern I share with Ria is navigating the challenges at the heart of assembling a history of gender transgression; part of that work involves contending with the intricacies of language and identity terms. While language can offer freedom in identifying and affirming identities, it

also lays out traps. It makes us identifiable, more visible. The visibility of trans people and trans culture has surged in the past decade, followed by a backlash in the form of legislative restrictions on trans individuals' access to crucial life-sustaining resources. Despite the contemporary surge of trans visibility, trans and nonbinary identities are not new. Gender transgression has existed throughout history, for as long as there have existed strict cultural norms related to one's sex designated at birth. Visibility comes at a cost, understood no better than by the figures included in Ria's series. These historical figures exemplify the struggles of people at odds with their time and place's gender conventions, and serve as reminders of the enduring challenges faced by those navigating the complicated intersections of identity, visibility, and societal norms. Ria's butch heroes intimately comprehend the price of visibility, having navigated lives where negotiating visibility or exposure could, at times, mean the difference between life and death.

Our understanding and use of language concerning gender have also rapidly evolved over recent decades. Language, especially in its connection to queerness, is in a perpetual state of flux. Take, for instance, the term "butch." "Butch" can be a desirable quality or a term of abuse depending on who is wielding it and at whom. Language proves inherently slippery, despite our earnest attempts to accurately convey our identities. Brodell's utilization of the term "butch" could encompass what might now be described as "trans masculine" or an AFAB (assigned female at birth) queerness that leans "masculine of center." Nonetheless, by embracing "butch," the artist seamlessly bridges historical figures to a more contemporary queerness, handling this nuanced term with the utmost respect and reverence.

Ria Brodell's approach in representing these historical figures in the form of saint cards offers a unique balm to the difficult lives and deaths many of these individuals faced. The format of the saint card connects the figures to Catholic saints, a nod to the persecution many endured during their lifetimes. It also implicates the society, in some cases the church, as perpetrators of that needless suffering. Ria's careful rendering of these figures becomes a form of remembrance and resistance against historical erasure. The artist recuperates these figures and offers them the respect and reverence that eluded many of them during their lifetime.

Searching the archive for traces of gender-transgressive lives reveals inherent challenges. Beyond the difficulties of navigating shifting language, the undeniable fact is that our lives have been underhistoricized. Often the historical record offers only fragments or traces, and if accounts do exist, they are frequently narrated by others in sensationalized, disrespectful, or dehumanizing ways. Ria Brodell's research-based artistic practice underscores the responsibility artists bear in critically and creatively unearthing aspects of marginalized history. While historical research informs their work, and each portrait's accompanying text, Brodell's creative approach is also vital in assembling and weaving together disparate pieces of information, presenting them in tender and beautiful ways. This approach is particularly valuable for queer and trans artists, who excel at seeking out and amplifying bits of information about the lives of those in the past who existed on the margins of their time and place. These are our *trancestors*. Or *butchcestors*, if you will. Despite cultural backlashes that attempt to violently erase or legislate us out of existence, trans and nonbinary identity is enduring.

Ria Brodell's approach is, in and of itself, undeniably heroic. In their project *Butch Heroes*, they adeptly navigate the complexities of language, visibility, and archival challenges, offering a creative and reverent portrayal of lives that defy traditional gender norms. Brodell's work stands as a powerful testament to the pivotal role played by trans and nonbinary artists in shaping historical narratives, celebrating resilience, and critiquing societal norms that persistently oppress queer and trans communities. Ria's work heroically immortalizes often-forgotten or barely known historical figures who fearlessly lived their lives on their own terms.

~Chris E. Vargas

Introduction

If you are familiar with the first book of this series, you know that I started this project in 2010 after making a painting for *The Handsome & The Holy* series titled *Self Portrait as a Nun or Monk, circa 1250*. At the time I was thinking about what my life would have been like as a trans, nonbinary, queer person had I been born into a different century. As a former Catholic, I knew that "homosexuals" were called to a lifetime of chastity or service to the church, and I knew that joining the Catholic church, becoming a nun or a monk, was one option for those who did not want to enter a heterosexual marriage or conform to the strict gender roles of their time. But I supposed that queer people of the past must have found other ways to live, and I wanted to find out how they did so.

I started by going to the LGBTQIA sections of local libraries, including Boston Public Library and the libraries at Tufts University and Boston College, and scouring books on our history for names and stories. I did not know at the time what form this project would take. Sitting in the aisles of those libraries, scanning the pages of books, most of the information I found was on white, male, European homosexuality. I grew increasingly frustrated with the lack of diverse representation.

Whatever this project became, I wanted to keep it personal; I wanted to find an answer to that initial curiosity, "What would my life have looked like had I been born into a different century?" I set specific parameters for my search, people in history with whom I could personally identify—people who were assigned female at birth, who did not abide by heterosexual norms, and whose gender presentation was more masculine than feminine. I wanted to show the breadth of our history, so I searched for people from diverse ethnic, societal, and geographic backgrounds. I wanted to find people whose stories were forgotten or

1

were unknown, so I looked for those who were born no later than the early twentieth century.

From the beginning, finding the names and dates of actual individuals was important to me. Names and dates can help to distinguish real people from fictitious accounts or myths. The inclusion of a name and dates meant that this was a real person, their life was fact, their story was not just one of the many generalized stories or legends. Finding the names and dates of actual individuals was the most difficult part of the research. It often required reading between the lines, because so much of queer history has been explained away as illness, friendship, opportunistic cross-dressing, or was rewritten or censored to suit the time. In *Butch Heroes* I included each person's chosen name(s) and given name for historical accuracy and to aid in further research. Many people used multiple names during their lifetimes. However, as the series has progressed, I've taken a more discerning approach. For instance, it was very hard to find information on Johnny Williams, because almost everything refers to a name that Johnny repeatedly denounced during his lifetime. Knowing Johnny's choice from his own words, I only use Johnny Williams throughout the text. Additionally, I began including those who were left unnamed. I kept coming across people's stories in the archives whose names were left unrecorded, and I noticed that often these were the stories of people within marginalized groups, including Indigenous people and people of color. There was enough information to know that their stories were true, and I kept wondering why their names were left out. Was it indifference, or was it racism or misogyny? Clare Sears points to a clear example in their book *Arresting Dress: Cross-Dressing, Law, and Fascination in Nineteenth-Century San Francisco*, in which a Chinese person is arrested for cross-dressing in 1869. Ordinarily the newspaper accounts would name the accused and go into great detail (see Jeanne or Jean Bonnet among others), but in this case, according to California historian Daphne Lei, "'not naming the Chinese' occurred frequently in popular writing at the time, working to expunge individual identities and construct 'the Chinese' as an undifferentiated mass."[1] I therefore felt it was important to depict the stories of those left unnamed as well.

The people I have chosen to represent are a diverse group. I use their narrative, and when possible their own voice, to establish their place in

this project. Some of them identified as women, others as men; some shifted gender presentations throughout their lives, while others embodied their own gender. Though some could be identified today with the terms "transgender," "lesbian," "nonbinary," "genderqueer," etc., these myriad LGBTQIA terms were not available to them during their lifetimes. Since it is impossible to know exactly how each person would self-identify using today's terminology, I view this project as an effort to document a shared history within the LGBTQIA community.

To determine pronoun use, I refer to their gender presentation or chosen name at each point in their story. If these are uncertain, I might use "they," or ideally just their name(s). This can make for cumbersome reading, but I feel that giving them the respect they deserve outweighs an awkward read.

Once I started to find stories of people that interested me and that fit within the project, I began making paintings. At first, I didn't know what form they would take. I made a series of vignettes, similar to those in *The Handsome & The Holy* series. In one I was sword fighting with Erauso, the Spanish soldier depicted in the first book, dressed in the period clothing of the seventeenth century. In another Erauso and I are sitting on a bench together, exchanging those heart-shaped best friend necklaces that break in half, one side reading "BE FRI," the other "ST END." I was still in this idea stage, just beginning my trips to the library, when I came across the fragments of an altarpiece of St. Stephen and St. Vincent on view at the Museum of Fine Arts, Boston. I had seen it while teaching drawing in the galleries to young people many times before. But this time I was struck by how nonchalantly St. Stephen looks back at us, while the stones lodged in his head cause blood to drip down his forehead. And St. Vincent, similarly apathetic, stands next to his millstone—the rope, having been cut from his neck, has fallen at his feet. I was instantly reminded of the holy cards that I grew up with. How much I loved their beauty, and the often humorous and dignified way they depicted the early saints and the violence they endured. They seemed to show examples of strength, of standing strong in one's convictions despite hardships. Using the format of the Catholic holy card for these paintings seemed the perfect choice to me.

Even though I am no longer Catholic, I still have a collection of holy cards that belonged to my late aunt. I loved going through the collection

with her and hearing her tell the stories of the saints. They are beautiful, intimate objects. They are delicately rendered with bold colors, and often include gold borders or ornate banners. They're handed out at funerals to help honor deceased family members, used to commemorate special events, or even just exchanged between friends and family as kindly gestures. When I was a kid, the saints depicted on the holy cards were presented to me as role models or heroes. They are figures from church history who are revered, and one is meant to look to them for guidance or to help find peace. When I was in my first year of undergraduate study at the School of the Art Institute of Chicago, I was homesick, I was struggling financially and not doing well in my classes, and my Gran sent me a holy card of St. Jude—the patron saint of lost causes. I remember not quite understanding why she sent that particular saint, but now I know it was a gesture to encourage hope. Now I can imagine what it would have been like to receive a card depicting Olga Tsuberbiller when I was struggling with math, or to learn about Joe Monahan as a young queer kid growing up in Idaho, or of the countless other stories of queer ancestors. For me, the format of the holy card is a perfect (and subversive) way to remember the lives of people who were forgotten and often abused during their lifetime.

Each painting was a new challenge and a different journey into history. I tried to get access to the original sources, which might be a newspaper article or a personal journal entry, for example. I looked for anything that included the subject's own voice, and hopefully a description of them. I tried to find other sources to verify the information. I summarize their stories here and include my sources so that others can access the original material. Each portrait involved extensive research into all aspects of the person's life, social class, occupation, clothing, and environment. I strove to be historically accurate and culturally sensitive to each individual.

The paintings were made using gouache on paper. I used descriptive accounts and other sources such as artifacts, maps, journals, paintings, drawings, prints, or photos from the time period to help me create a real or imagined portrait of the subject. Figuring out how to represent aspects of their lives visually was the best part. For example, I've been in the basement of the Cabot Science Library at Harvard, handling and taking notes from one of Olga Tsuberbiller's textbooks; I scoured old

maps of Stockholm trying to determine what the skyline would have looked like from the Haymarket in 1679; I examined buffalo robes from the National Museum of the American Indian and at the Peabody Essex Museum; I watched YouTube videos of a father and son team (with thick Scottish accents) demonstrating how to properly plaster a traditional Scottish house for John Oliver's portrait; I researched Indigenous dip net fishing techniques specific to the Fraser River in British Columbia; I wrote to the former owners of the Mandarin/Sun Sing Theatre (now a shopping center) in San Francisco so I could accurately depict the beautiful theater's facade in Esther Eng's portrait. I loved gathering the details.

I have chosen the term "Butch" for my title because of its specificity and its expansiveness. It has a specific history within the LGBTQIA community, and is also used within the cisgender and heterosexual community. In my personal history, it has been slung as an insult and used as a congratulatory recognition of strength. In addition to the term's traditional associations of being masculine in appearance or actions, I chose to use "butch heroes" to indicate people who were strong or brave in the way they lived their lives and challenged their societies' strict gender roles. Since the first book of *Butch Heroes* this title has caused some consternation for me, with some craving a more open title such as *Gender-Variant Heroes*, and others clinging to its specificity within the lesbian community. Terminology is expansive, difficult at times, fascinating and ever-changing. What title might encapsulate the varied lives of the people I have depicted in this series? Regardless, I know they are *Heroes*!

There are so many stories that I wish I could have included. There were some on whose research I stopped and started and that ultimately stayed in my files: Paul Beach, Charles Winslow Hall, Nicholas de Raylan, Ulrika Eleonora Stålhammar aka William Edstedt, to name a few. And those I wish I had found more information for, like the story of two imprisoned lovers in India, or Co'Pak, a Klamath person who had lost their wife and was in mourning, or Wong Ah Choy, a stowaway on a ship from Hong Kong that entered San Francisco harbor in 1910, or Dick/Mamie Ruble, who was sent to an insane asylum for declaring that they were not a man or a woman. There are some stories I included even with the limited information that I could find, such as "Papa" and Tom. I had enough information to show me that they were factual stories, they

piqued my imagination, and both stories represented aspects of lives that I had not depicted before—like parenting.

Unfortunately, many of the stories depicted in *Butch Heroes* are incomplete, and few offer happy endings. This is the nature of the source material; many of the lives depicted I've been able to find because of their notoriety. And that notoriety often came because of an arrest, a trial, or some other form of public exposure like a "Deathbed Discovery," a common newspaper headline. After their time in the spotlight, their stories often fade into history without further record. Though it is frustrating not to know what became of them and disheartening to read so many unfortunate stories, I like to find comfort in knowing that with all the stories I was able to find, there are thousands more that lived their lives as they pleased out of the public eye.

A lot has changed in the world since I started this series in 2010. There is more information available on the internet and social media, thus more visibility for better and worse. What started as a personal question, a curiosity, and a painting series became something much larger. It led to finding peace within myself that I never anticipated. Through the research into this history, I have become more comfortable with myself, with who I am, and with my place in this world. While searching for the answer to one question I found the answer to another that I didn't know I was asking or needed answered. Learning about the lives of our ancestors has assured me that I am who I am supposed to be, that we belong here, that we have always been here and that we have always found ways to live our lives. I am excited by how many queer ancestors there are!

~Ria Brodell

List of Portraits

THE PAINTINGS

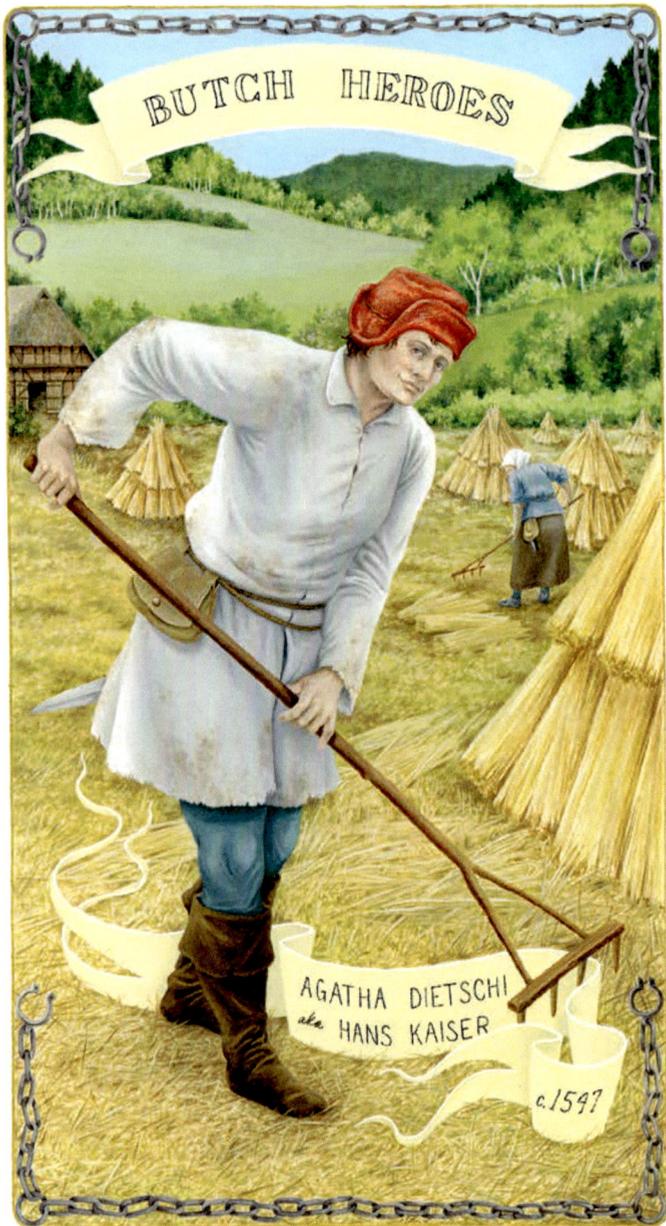

Agatha Dietschi aka Hans Kaiser c. 1547 Germany, gouache on paper,
11 × 7 inches, 2018.

Agatha Dietschi aka Hans Kaiser

Hans Kaiser, also found under the name Schnitterhensli, worked as a migrant farm laborer in the Danube valley of Germany. He was married to a woman named Anna Reuli, who was also a farm laborer. Within their community they were seen as a model couple in a happy marriage. In reality that was not the case.

Hans was arrested in Freiburg im Breisgau in 1547 after an investigation brought about by Anna.

Nearly two years into their marriage, Anna had discovered that Hans had once been known as Agatha Dietschi. Upon this discovery Anna apparently tried to convince Hans to go back to living as Agatha, even offering to procure Hans women's clothing. Hans refused, declaring that he was bewitched and could never "live as a woman or love a man."[2] Despite this development in their relationship, they stayed married for eight years.

However, at some point Anna met Marx Gross. The relationship between Anna and Marx made Hans extremely jealous. Marx and Anna began threatening Hans in order to secure Anna a divorce. Eventually Anna exposed Hans, bringing about an investigation and an eventual trial.

At the trial, Anna (who had also been arrested) first said that she did not know her husband's sex, and then she admitted she had found out, but stayed quiet out of fear of the repercussions from the community. She also insisted that they had never had sexual intercourse. Hans, on the other hand, was found in possession of a "phallic tool" and admitted to using it numerous times with Anna. Witnesses also came forward having seen Anna and Hans engaged in "erotic play" in the barn.[3] Marx came to Anna's defense testifying that she was a virgin. The trial also revealed that Hans had been married before, both to a man (as Agatha) and to a woman.

The court may have believed that their marriage had not been consummated, because not only is there no record of a punishment for Anna, but Hans was sentenced to stand in the pillory with an iron collar and was banished from the city, a considerably light sentence given that similar situations were punished with execution during this time.[4]

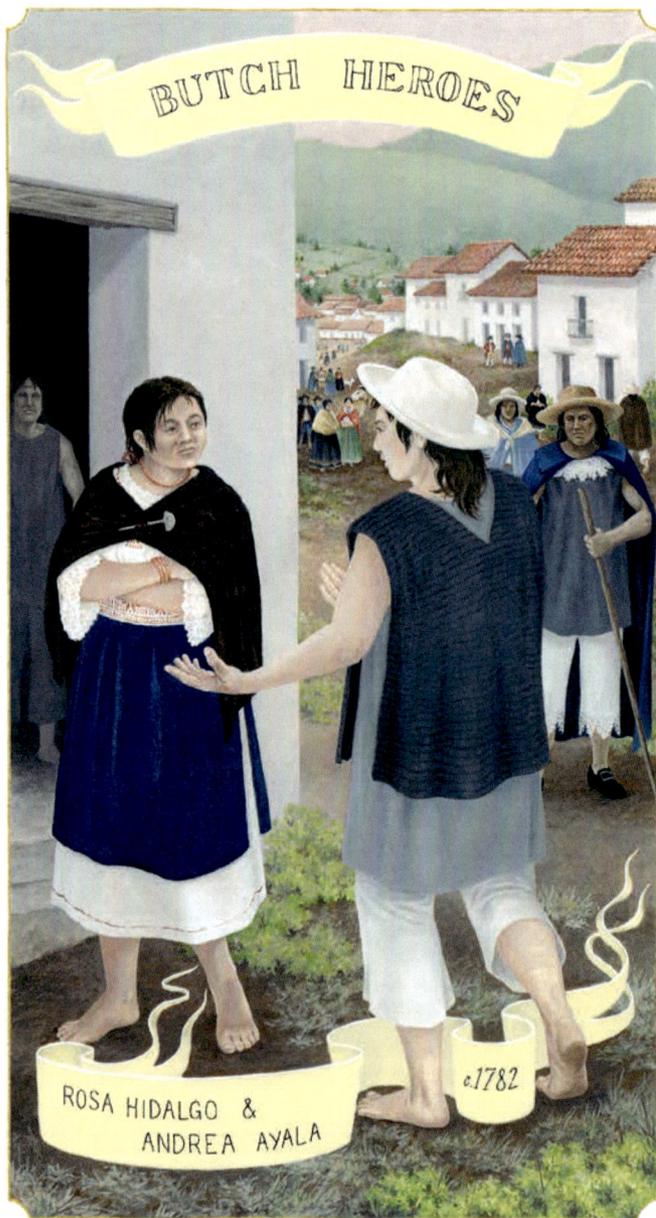

Rosa Hidalgo and Andrea Ayala c. 1782 Ecuador, gouache on paper,
11 × 7 inches, 2019.

Rosa Hidalgo and Andrea Ayala

On November 30, 1782, Rosa Hidalgo and Andrea Ayala were arrested and accused of having an "illicit, sodomitical relationship"[5] in Quito, Ecuador.

The complaint was made by Hidalgo's husband Leonardo Zapata after a very public incident in which Andrea Ayala appeared at his house, dressed in male clothing, yelling, whistling and beckoning for Hidalgo from the street. A fight ensued, resulting in Hidalgo leaving with Ayala and an embarrassed Zapata going to the barrio alcalde to report the event.

Hidalgo and Ayala had been together off and on for over six years, with Hidalgo periodically returning to Zapata to avoid any appearance of an abandoned marriage. Witnesses testified that there was often "physical violence motivated by jealousy between the two women, and that they were also publicly affectionate and known to 'carouse together.'"[6]

During their confessions, both Hidalgo and Ayala denied that there was anything illicit about their relationship. Ayala denied any gender transgressions, and both explained any violence in their relationship as the result of accident, the fault of men, or jealousy.

Despite witness testimony and the judicial officials' clear belief in the sodomitical nature of the relationship, authorities could not provide proof due to "penetrational ambiguity."[7] The pair had spent two months in jail when Hidalgo's husband recanted his accusations. He requested Hidalgo be set free because he could not afford to pay tribute on his own (both Zapata and Hidalgo were Indigenous and as such they were required to pay tribute to the Spanish crown). Hidalgo was released into the custody of Zapata, warned of the severity of her crime, and threatened with the death penalty should she be accused again. Ayala was similarly threatened and due to her status as a single woman she was placed in the Monasterio de la Concepción to "live honestly and in fear of God."[8]

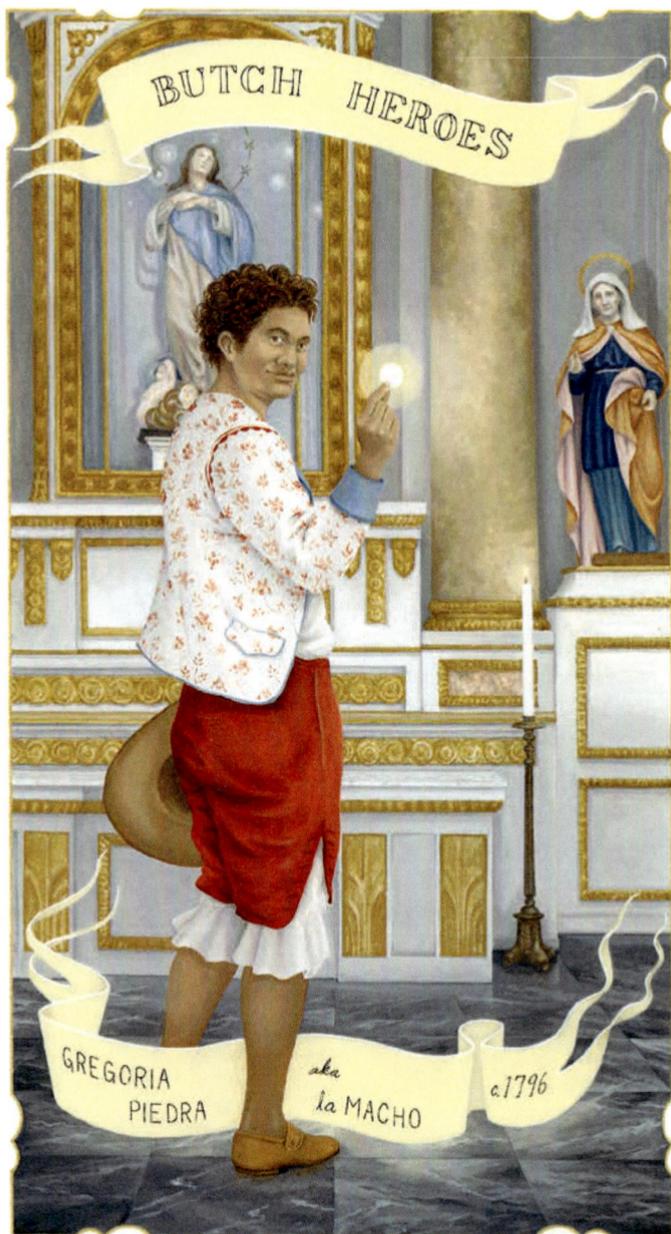

Gregoria Piedra aka la Macho c. 1796 New Spain (Mexico), gouache on paper, 11 × 7 inches, 2018 Private Collection.

Gregoria Piedra aka la Macho

On Holy Monday, 1796, in Mexico City, Gregoria Piedra was seen taking the Eucharist out of their mouth after receiving Holy Communion. This act was made more egregious because Piedra was dressed as a man. The witness to the act said Piedra held her gaze, revealed their disguise, and ran out of the church laughing.

The parish priest went to the Holy Office and demanded that Piedra be arrested for such a sacrilegious crime. When they found Piedra, still dressed in men's clothing, they were watching the Holy Monday procession and blowing out the candles of those who were in the procession.[9] Piedra was detained in the court jail while the inquisitors gathered more information. In order to determine whether crimes against the faith had been committed, they specifically sought information on Piedra's Catholic faith. Upon further investigation it was found that Piedra had been incarcerated several times for various offenses, among them provocation, dressing as a man, and taking communion multiple times during the same mass.

Piedra was well known in the neighborhood. According to neighbors they were more of a man than a woman. Piedra was known by the nickname "la Macho" because of their masculine physical appearance and demeanor. They had many female companions and were seen more often in the company of women than men. Piedra often played pelota, had no address or occupation, and it was rumored that they had served in the military as a man, either in the cavalry or the regiment of the pardos.[10]

Though Piedra was seen as insolent, irreverent, and mischievous, the inquisitors did not have enough evidence to charge them with crimes against the faith. Piedra's actions were seen as those of a delinquent rather than a sinner, since Piedra was still a devout and practicing Catholic. However, the investigation had revealed Piedra's "inclination towards women," which caused a considerable amount of confusion.[11] What was the crime? Under whose jurisdiction did it fall? Since it was not a crime of faith the Holy Office did not want to deal with it, and the Royal

Court had no legal precedent to follow, so they did not know what to do with Piedra either.

Piedra was held in jail while the case was pushed between the Royal Court and the Holy Office, sometimes being forgotten altogether in the bureaucracy of the colonial government, until 1798 when Piedra was transferred to a women's correctional facility. Though purported to be an institution that educated and reformed inmates, it was really a penitentiary: fellow inmates were thieves, adulterers, and murderers. Piedra was sentenced to eight years in prison for crimes of a "dissolute" and "perverted" woman.[12]

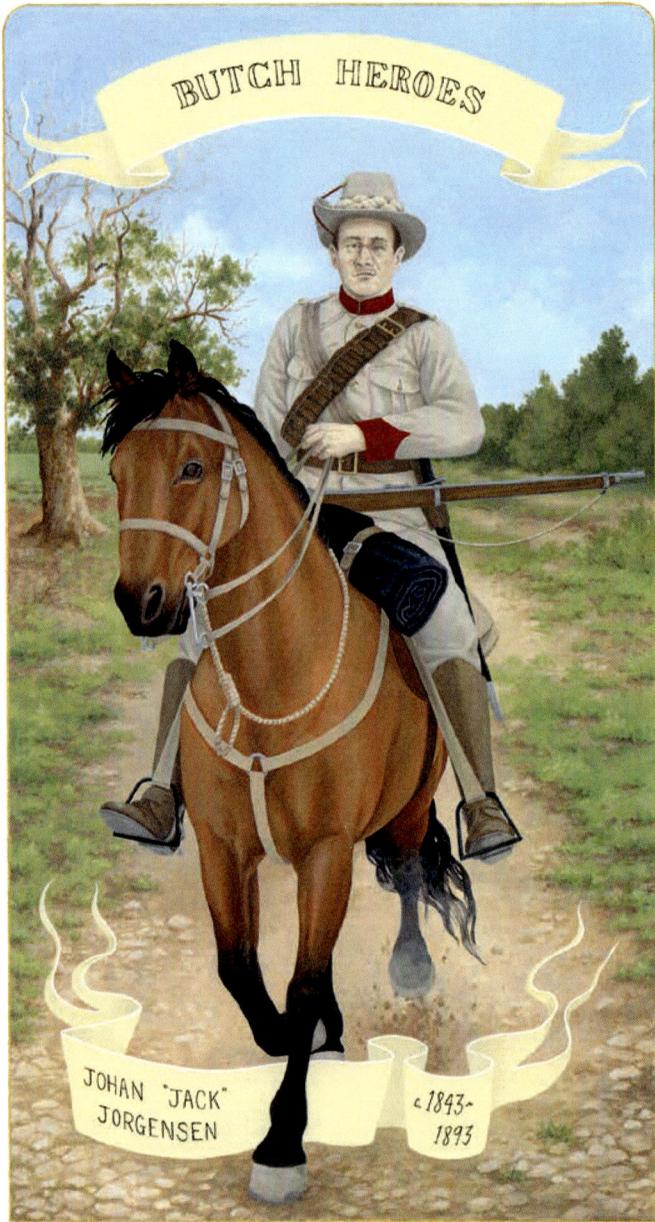

Johan "Jack" Jorgensen c. 1843–1893 Australia, gouache on paper,
11 × 7 inches, 2023.

Johan "Jack" Jorgensen

Jack Jorgensen was born May 20, 1843, in Berlin. His father was a Danish cabinetmaker, and his mother was German. He died in Runnymede East, Victoria, Australia in 1893. He worked as a farmer, bullock driver, laborer, and cook at various times in his life.

In 1873 Jorgensen was arrested for wearing male clothing and brought before the Heathcote (Victoria) Police Court. A farmer he worked for testified that he knew him as "Joseph" and was pleased with the work he performed. Jorgensen pleaded with the court to let him remain in male clothing, explaining that he had worn it all his life and that when in women's clothing he was accused of being a man. The court purchased women's clothing for him, and he was ordered to stay dressed as a woman.[13] So Jorgensen moved thirty miles away and resumed his life in male attire.

He was described as stout and broad set, with an awkward gait, a stubby moustache, an even temper, and a falsetto voice. He was strong and smart with his hands. He spoke broken English with a strong German accent. His face was scarred from an injury sustained either from serving in the Franco-Prussian war or being kicked in the face by a horse—the story changed depending on who did the telling, Jorgensen or his sister.

Jorgensen was a romantic. He had always wanted to marry and have a family. He fell in love many times. At least once, he asked for the hand of a young woman he took a fancy to, but the girl's father treated his proposal as a joke and her mother was reportedly "enraged." His proposal was rejected.[14] Many of the local boys and townsfolk treated Jorgensen with disdain, teasing and tormenting him over his appearance and his interests in women. Some may have suspected his sex, likely because of the sound of his voice.

Jorgensen joined the Victorian Mounted Rifles shortly after they were formed in 1886. An article in the *Bendigo Advertiser* published after his death describes the pride he showed in his enrollment. "She [sic] would ride in on her [sic] bay charger, arrayed in her [sic] uniform, and carrying her [sic] firearms, etc., with all the pomp and ceremony imaginable . . ." However, the other members of the company were less than accepting of Jorgensen's involvement and complained to their officers

about his appearance, saying, "it was ludicrous, and raised the risible faculties of spectators when the company was on the march."[15] Regardless of his physicality Jorgensen was a good shot and a hard worker and despite being ostracized he remained in the Rifles until 1891. Colonel Price, upon hearing of Jorgensen's death, said he regretted Jorgensen's resignation because he was "a keen soldier, a most patient one, and always ready to volunteer for any hard work." Major Hoad remembering Jorgensen said, "It is a most wonderful thing, Jorgensen had enormously big powerful arms and was capable of lifting great weights with ease. Whenever there was any particularly heavy work to be done Jorgensen was always called on and readily responded."[16]

Jorgensen was frugal, and seemingly did well for himself. He purchased eighty-six acres of land. He lived upon it and cultivated it with the help of hired hands. After a time, he sold the land to another farmer. Near the end of his life, he lived with five men in a "rickety old hut." For most of his life Jorgensen was in good health, but for the last seven or eight months he was unwell. He continued to work, but eventually he was too sick to leave his bed. He summoned a doctor, but he did not want to be examined. Jorgensen's living conditions, sleeping on the ground under old blankets, were contributing to his poor health, and the doctor insisted Jorgensen be sent to the Bendigo hospital. Jorgensen refused. The doctor visited him again a few days later, and again Jorgensen did not want to be examined, but given his symptoms the doctor diagnosed rheumatic fever and asthma. Jorgensen's condition only worsened and soon another farmer, Mr. Bailey, went to the constable to inform him that Jorgensen was gravely ill and needed care. Constable Bennett explained that he could not force Jorgensen to go to the hospital unless he had him arrested, which both agreed was unwarranted. The two of them went with an administrator from the hospital to try to convince Jorgensen to go to the hospital. Jorgensen again refused. Within a few days Jorgensen was dead. The men that he lived with carefully laid out his body and went for the doctor. Cause of death was complications of rheumatic fever, asthma, and exposure to the elements.

Jorgensen left all he possessed to two farmers in Runnymede East, Mr. Weeks and Mr. Hunter. His sister came from Melbourne to identify the body. They had not seen each other for fourteen years.

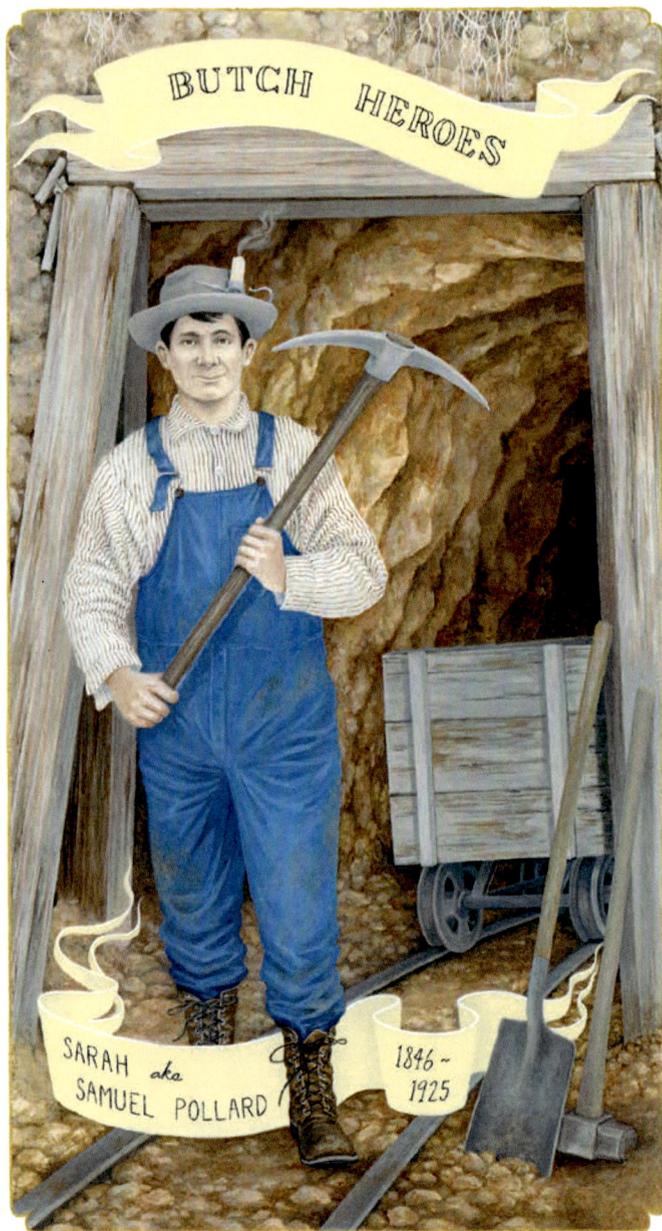

Sarah aka Samuel Pollard 1846–1925 United States, gouache on paper,
11 × 7 inches, 2020. Collection of the Fitchburg Art Museum.

Sarah aka Samuel Pollard

Sarah Pollard, who sometimes went by Tom as a young adult in Bing-hamton, New York, was born on May 25, 1846, to a prominent family. Pollard often wore male clothing, smoked cigars, and lived with female companions. This made them the frequent topic of gossip. Their size and physical appearance, "more like a man than a woman,"[17] meant they were often the recipient of children's taunts. They were a large person, with a deep, hoarse voice and a faint mustache, earning them the epithet "the Great Eastern" after a famed steamship.[18]

Pollard worked in New England shoe factories in the late 1860s. In the early 1870s they opened their own millinery establishment. They moved west around 1875 after the business failed. They were in Colorado for a short period, operating a cigar shop and holding other odd jobs, before settling in Nevada.

In Nevada, Pollard established themself as Samuel Pollard and worked at the mines near Tuscarora in Elko County. In 1877 Sam met Marancy Hughes whose family had settled in Nevada to work the silver mines. Marancy's family did not approve of her relationship with Sam, but that did not deter the couple from eloping on September 29, 1877. Their marriage seems to have been happy for the first six months, until Marancy decided to expose Sam. It is unclear what provoked Marancy, but she wrote to the *Tuscarora Times-Review* demanding that Sam be arrested and punished. The story spread to papers around the country, many of them referring to Sam as "What Is It"[19] or simply "It."[20]

Sam was arrested and charged with "perjury in having sworn falsely when the marriage license was obtained."[21] After Marancy testified at the trial she asked to see Sam and "immediately threw her arms around the neck of Pollard, whom she fondly kissed, and in the wildest excitement begged that she might be permitted to remain there and not be sent back to the house of her relatives, saying that she desired to remain with her husband."[22] Sam was released and the two of them left the court as deputies held off Marancy's angry grandmother.

From 1878 to 1880 Marancy and Sam's relationship was arduous. The publicity caused stress, and Marancy's family caused trouble, resulting at one point in a gunfight between Sam and one of Marancy's brothers.

Sam was also traveling. In 1879 they had begun a lecture tour. During the first half they would appear on stage as Samuel and after intermission as Sarah. They toured around Nevada telling their story. By June of 1880 Sam and Marancy had separated.

In 1883 Pollard is recorded as living in Polk County, Minnesota and working as a farmer. Newspapers noted, "Minnesota rejoices in the possession of a unique character, Sarah Pollard, who is one of the most successful farmers in Polk County, where she owns half a section of land which she works herself with no help from men except in harvest season.... She does her own plowing, seeding, and harrowing, operates her large farm with no other counsel than her own good judgment."[23]

By 1885 Pollard was living with Helen Stoddard, a schoolteacher. They are recorded as each other's "partner" and "companion" in the censuses from 1900 to 1920. Pollard died on February 12, 1925, with Helen following on April 10, 1959. They are both buried in Rosehill Cemetery in Mentor, Polk County, Minnesota.

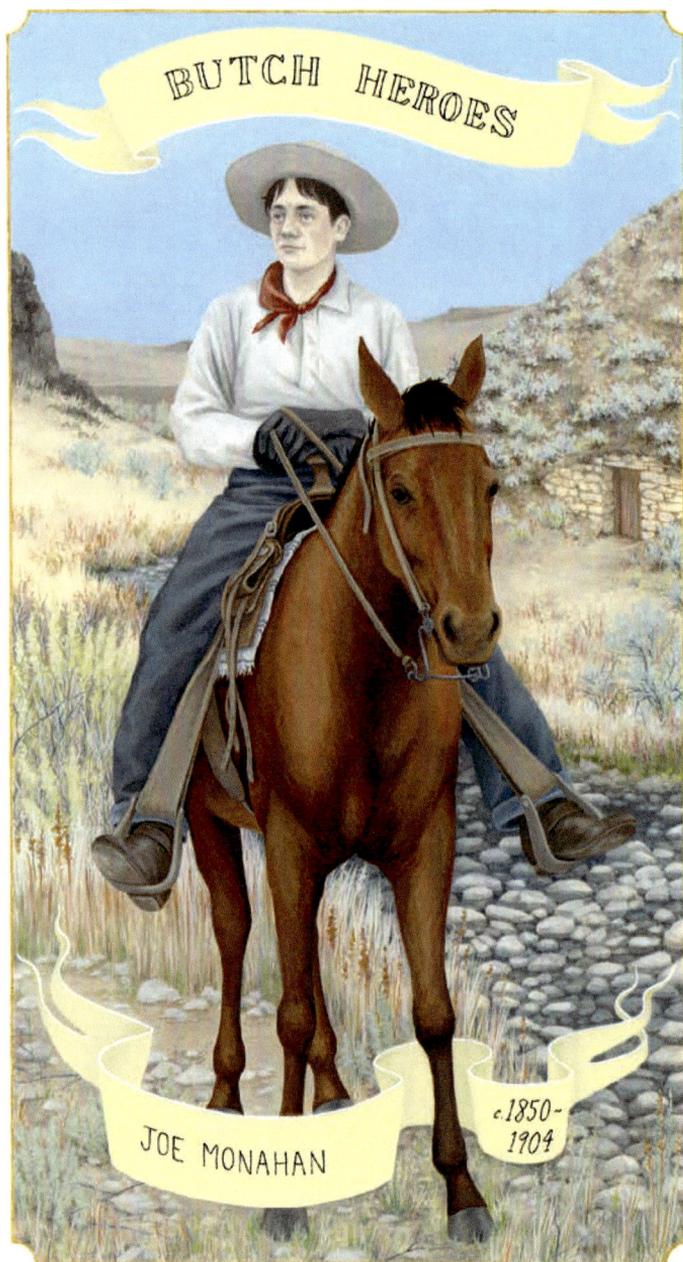

Joe Monahan c. 1850–1904 United States, gouache on paper,
11 × 7 inches, 2021.

Joe Monahan

Joe Monahan lived in and around the Owyhee Mountains of southwestern Idaho for nearly forty years.

He was around fifteen years old when he moved to the mining town of Silver City, Idaho in 1867, working first in a livery, then a sawmill, and eventually mining. He did well for himself, accumulating around 3,000 dollars. Unfortunately, he placed his trust in a mining superintendent who stole his savings. This led Monahan to take up odd jobs and sell milk and eggs from his cow and chickens until he could save enough to start over. In 1883 he moved to Succor Creek.

In Succor Creek he lived in what most considered poor conditions. His home was described as little more than a dirt-floor chicken coop or dugout. He had forty acres, one cow, one horse, and he saved his earnings carefully. Soon he was doing well for himself.

Though he was small in stature, beardless, and soft-spoken, with small hands and feet, he was an accomplished horseman and could handle a revolver and a Winchester rifle with ease. He also served several times as a juror and voted in every election. Monahan was a very private person, and his neighbors hardly knew anything about him. But he was a well-liked member of the community; the cowboys of the area "treated him with the greatest respect, and he was always welcome to eat and sleep at their camp."[24]

In the fall of 1903, when ordinarily he would have been driving his small band of horses and herd of cattle to their winter feeding grounds on the Roswell Bench and into the Boise Valley, he found himself falling ill. He sought help at the neighboring ranch of the Malloys. He had often stopped off at the Malloy ranch during his fall cattle drive. This year, however, he was never able to recuperate, eventually succumbing to his illness and dying on January 5, 1904. He was roughly fifty-three years old.

When neighbors were preparing his body for burial, they discovered what some had always suspected. Unsure what to do, they quickly buried Monahan without ceremony. "Not a word was spoken, not a word read, not a prayer offered," a dismayed friend wrote of Monahan's funeral, lamenting that no one could know why Monahan lived the way he lived and that "'Little Joe' never did anyone harm."[25]

Another friend, a cowboy named William Schnabel, sought to find more information about Monahan's family, hoping to pass his modest estate on to his next of kin. He remembered letters Monahan had addressed to Buffalo, New York and reached out to Buffalo's chief of police. The letter began, "Dear Sir, there died near here a little man, who has been known by all frontiersmen, such as miners and cowboys, as 'Joe Monahan.'"[26] Upon receiving the letter, the police turned it over to the local paper who in turn published it on page one in the next edition. This led Mrs. Katherine Walter to come forward with the explanation that she was "Johanna Monahan's" foster mother. She had taken Monahan in when he was eight years old. According to Walter, Monahan always dressed in boy's clothes and earned a living by selling papers and running errands. At age fourteen Monahan had headed West to the gold-rush. Correspondence found with Monahan's belongings after his death show this part of his history to be true.

After those first reports in the newspapers, facts quickly become obscured. Historian Peter Boag writes, "The mass-circulation press, most notably the *American Journal Examiner*, fictionalized his womanhood, femininity, and heterosexuality. Later storytellers, playwrights, and filmmakers have uncritically accepted what period newspapers reported."[27] Even his name was changed from Joe to Jo. Accounts of lives like Monahan's were commonly fictionalized in newspapers and novels at the turn of the twentieth century—much like the stories of Sammy Williams and Mr. and Mrs. How.[28] Heterosexualizing or feminizing these lives helped to assuage society's anxiety around any sexuality or gender that seemed unaligned with what was acceptable. Newspapers profited from the young-woman-spurned-by-love trope. Unfortunately, that storyline lives on, most notably in the 1993 film *The Ballad of Little Jo*, which relied on those fictional and sensationalized accounts of Monahan's life to tell yet another story of a woman spurned by love.

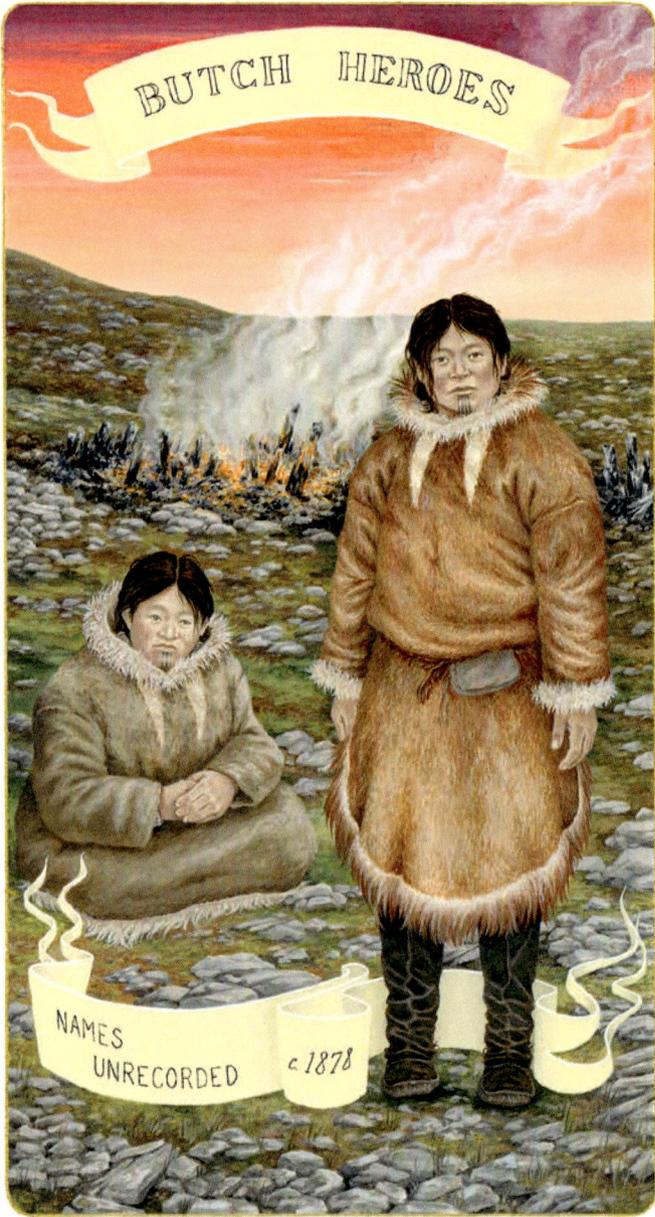

Names Unrecorded c. 1878 Iñupiat, gouache on paper, 11 × 7 inches, 2019.

Names Unrecorded

William H. Dall describes a young woman, "quite fine-looking, and of remarkably good physique and mental capacity,"[29] in his observations of Eskimo [sic] living in the Norton Sound region of northwest Alaska in the late nineteenth century. He does not record her name, nor the name of her partner.

> She said that she was as strong as any of the young men; no one of them had ever been able to conquer her in wrestling or other athletic exercises, though it had more than once been tried, sometimes by surprise and with odds against her. She could shoot and hunt deer as well as any of them, and make and set snares and nets. She had her own gun, bought from the proceeds of her trapping. She did not desire to do the work of a wife, she preferred the work which custom among the Eskimo allots to men. She despised marriage; held she had the right to bestow favors where, when and to whom she pleased, as fancy prompted, or not at all.[30]

 She found a partner "in a smaller and less athletic damsel"[31] and the two of them made a home together. They attempted to live, trade, and go about their lives despite the strong disapproval from their community. Under constant harassment, particularly from the young men, they were always alert and able to thwart any attempts to upend their home life.

When deer hunting season came, they set off for the mountains. Upon their return they found that their home had been reduced to ruin.

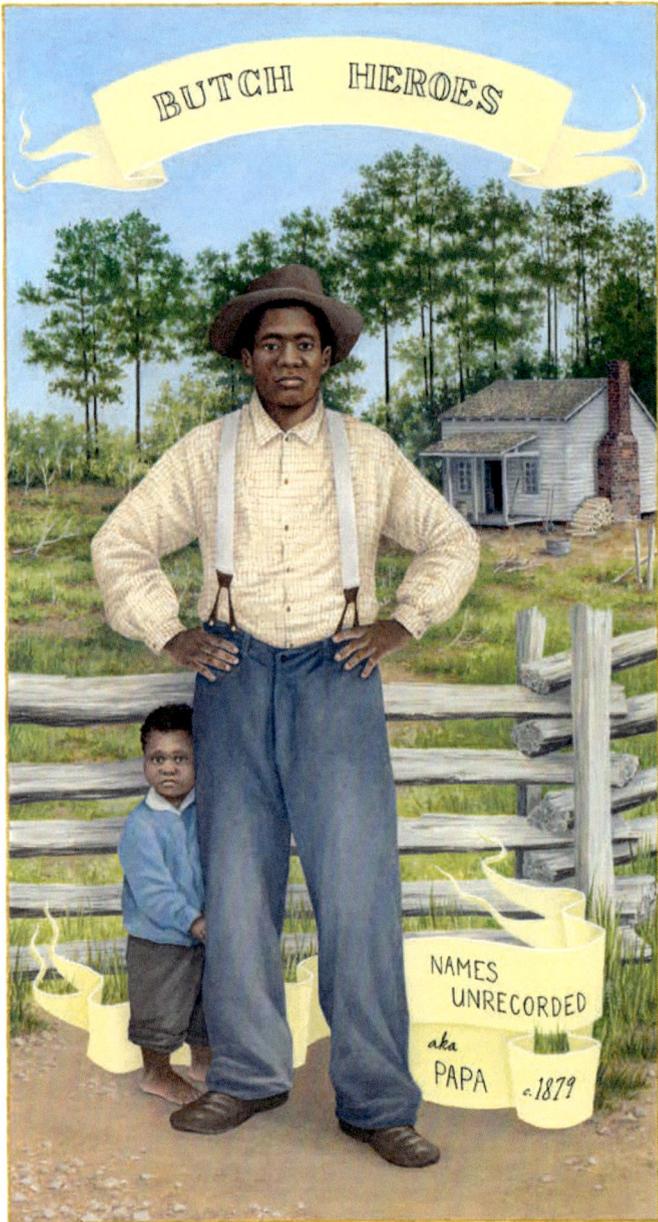

Names Unrecorded aka Papa c. 1879 United States, gouache on paper,
11 × 7 inches, 2023.

Names Unrecorded aka Papa

A short report in *The Tarborough Southerner* out of Kinston, North Carolina, from September 20, 1879, reads:

> There is a colored woman here who was raised as a boy; does not recollect when she began wearing male clothing; still dresses and acts like a man; does man's work and bears a man's name. She has an aversion to being with women, or doing their kind of work, and says she would go to the penitentiary before she would wear a bonnet. She is a mother but not at all motherly, and her child calls her papa.

Another brevity published in the *Wilmington Morning Star* three years earlier mentions the arrest of a "woman dressed in male attire" from Johnston County. They had a three-month-old child with them, and upon arrest they were sent to the poorhouse.[32]

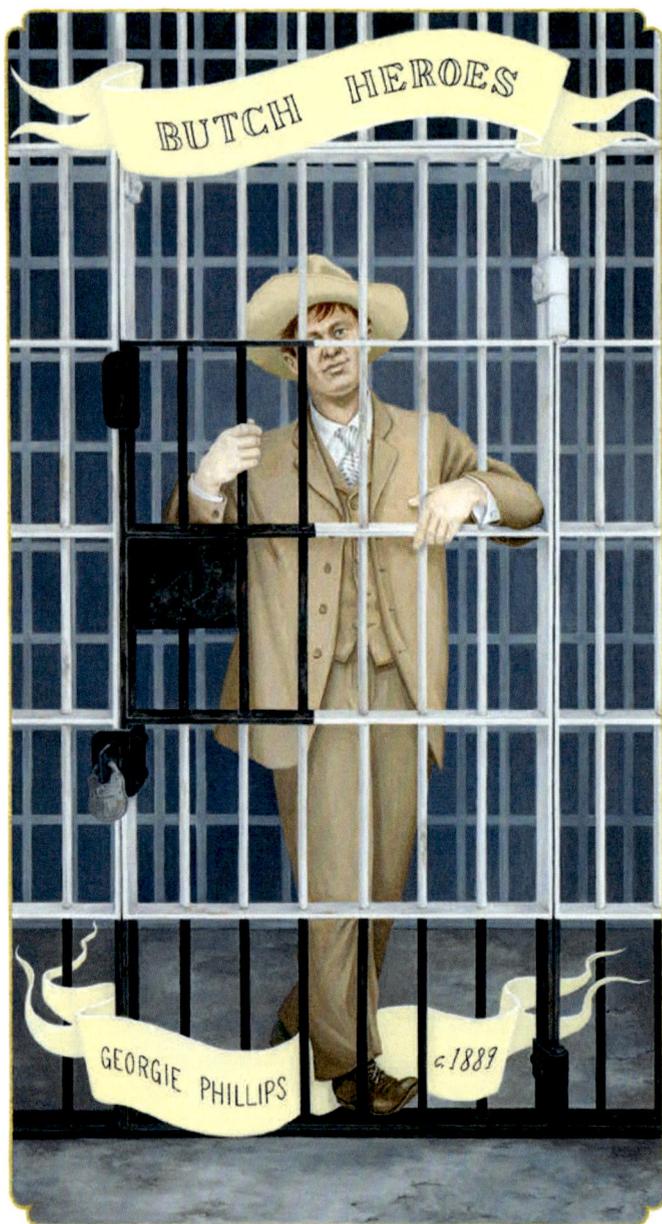

Georgie Phillips c. 1889 United States, gouache on paper, 11 × 7 inches, 2019.

Georgie Phillips

In 1889 Georgie Phillips was arrested in Denver, Colorado for wearing male clothing. They served sixty days in jail.

Georgie Phillips had been cited or arrested numerous times over the past ten years for wearing male clothing. They were described as making "a rather good looking seventeen-year-old boy" in a "new spring suit and cowboy hat."[33] Georgie was small, knock-kneed, and had short red hair, which made them a fairly recognizable target for Denver's police force. On one occasion in 1887, Georgie and their girlfriend, described by the *Denver Times* as a "country maiden," were looking for a room. Georgie knocked on the door to inquire about the rent, only to discover that the landlord was a detective they had encountered many times before. The two quickly turned and ran.

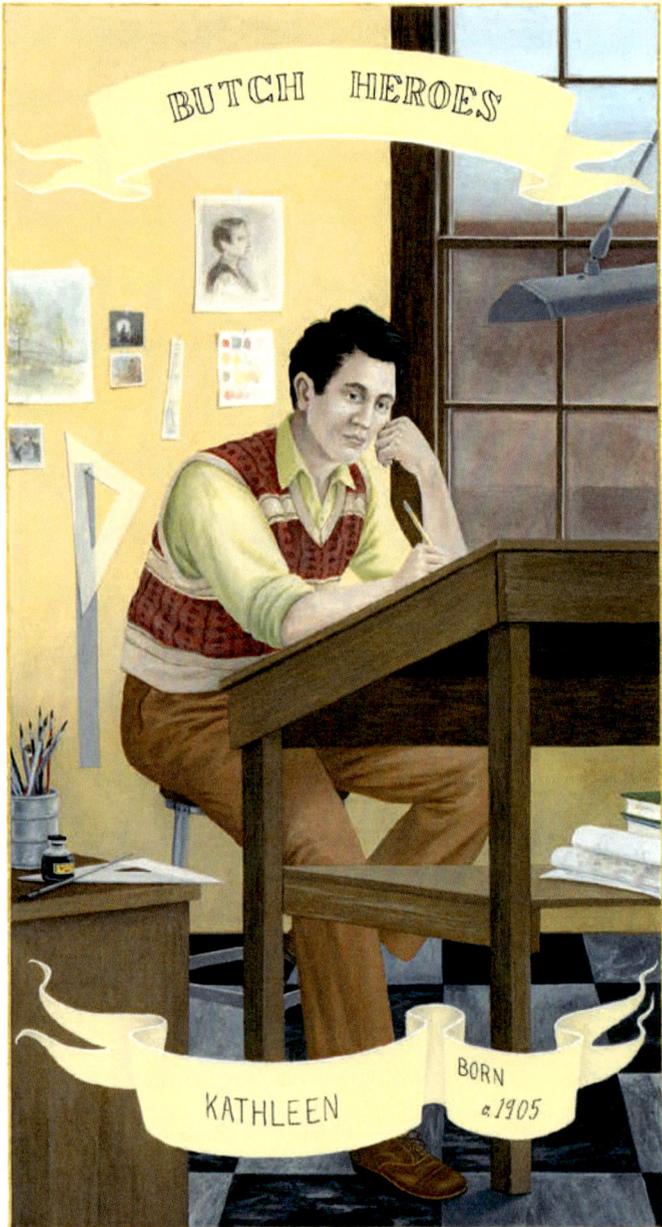

Kathleen born c. 1905 United States, gouache on paper, 11 × 7 inches, 2021 Collection of MIT List Visual Art Center.

Kathleen

Kathleen M.'s[34] childhood and adolescence were spent both in the city and on her father's farm. One of six children, with an older brother and four younger sisters, she was of a family of primarily Dutch, Irish, and French descent.

On the farm, Kathleen could ride horses, climb trees, go on long solitary walks, play sports, and do all the "rough out-of-door things." She often dressed in her brother's clothes and was described as a gawky and athletic tomboy. She "never took school as it was intended," instead going to class sporadically, finding the majority of the teachers unjust and discriminatory. When she was eighteen, she enrolled at an art institute.

In *Sex Variants: A Study of Homosexual Patterns*, conducted by George W. Henry and sponsored by the Committee for the Study of Sex Variants, Kathleen was described as bringing the "breezy atmosphere of an aggressive business woman."[35] She was exceedingly masculine, tall and thin, with square shoulders and a raucous voice. According to the study, she had a swaggering walk and was frank and direct when she talked about her life and family. The study took place in New York City in the 1930s, at which time Kathleen was around thirty years old.

After about one year at art school Kathleen moved home again. Her father couldn't afford the art school and wanted her to find a job. She continued her studies part-time at a nearby university while living at home. Eventually, she decided she couldn't live at home any longer and left to live with a group of artists.

She began putting together exhibitions and meeting new people who introduced her to different ways of living. In the past she had had relationships with men, but they had "meant nothing" to her and she had been completely uninterested. One of them had called her a lesbian. At the time, she had never heard the word before, but now she was being introduced to "famous lesbians" and was enjoying her sexuality for the first time.

She soon found herself in a difficult relationship with a woman who "tried to make a lady out of me—to make me wear long hair, fluffy clothes, and high heels. We lived together for five years but there was constant controversy over my appearance and rarely peace in the home."[36] The

woman was often ill. Kathleen cared for her and supported them by working as a commercial artist. Upon finding out that the woman was unfaithful and untruthful to her, Kathleen became "disillusioned." She began drinking excessively. "During this period I flirted a good deal with anyone who came along, I would make a definite play to get them, sleep with them and then leave them."[37] After about six months, Kathleen decided to stop drinking. Her "normal" friends and her psychologist told her she should go back to men, but she wasn't interested.

At the time of the *Sex Variants* study, Kathleen was in a relationship with an actress, whom she had been living with for two years and with whom she had adopted a baby. They were committed to each other and enjoyed each other's company. During the study, recalling when she was thirteen and an analyst told her mother that she had homosexual tendencies, Kathleen said, "When Mother told me about homosexuality she told me it was abnormal, that there was no satisfaction and that the result was an empty life. I disagree. I don't care what people think and I avoid people who ask personal questions. My personal life is my own affair. Since we have been living together our lives are fuller and happier. We create things together and we are devoted to our baby."[38]

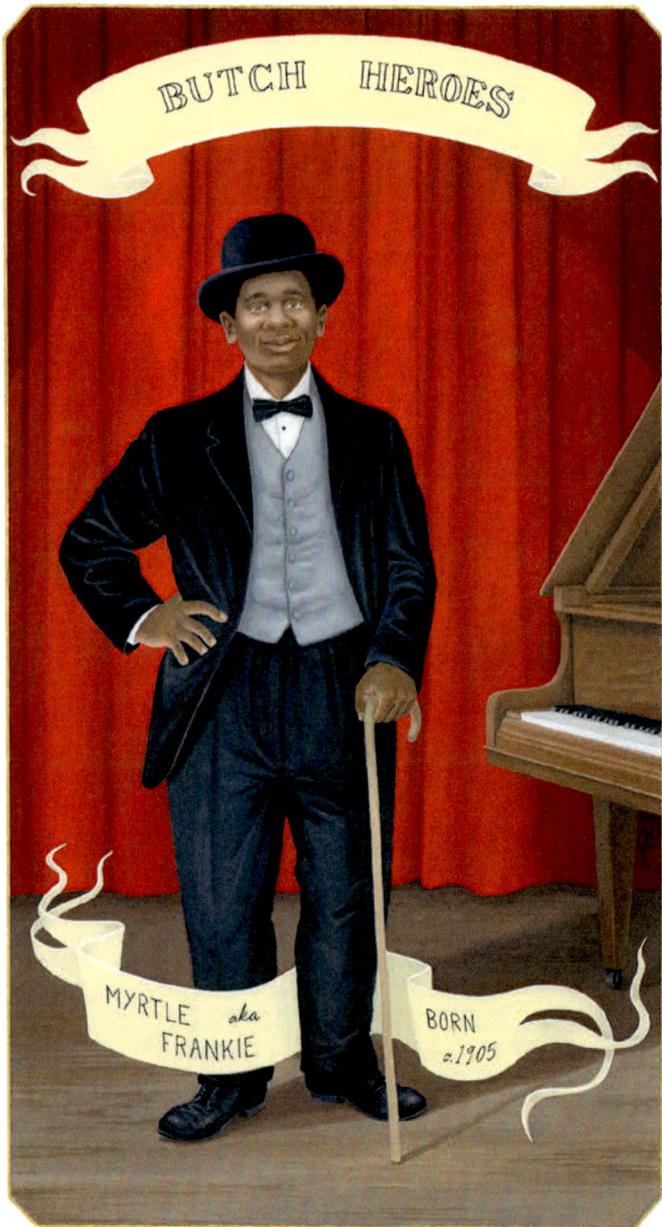

Myrtle aka Frankie born c. 1905 United States, gouache on paper, 11 × 7 inches, 2021 Collection of the Lucas Museum of Narrative Art, Los Angeles.

Myrtle aka Frankie

Myrtle K. was the pseudonym used in George W. Henry's study *Sex Variants*. Known to most people as Frankie, and described as always smiling and extremely amiable, they were thirty years old when they participated in the study.

Frankie was born in Virginia, where their family had lived for generations, the descendants of enslaved Africans. They were very close with their father. He was very stern, but Frankie was his favorite child. He died when Frankie was ten. Their mother was a devout Baptist and very involved with the church. Frankie often ran away from home to avoid their mother's punishments. Frankie's uncles taught them to ride and shoot. They loved animals, especially horses. They often wore their brother's clothes, loved to play baseball, climb trees, and liked to fight with boys. "I was a thorough tomboy. . . . I always wanted to be a boy."[39]

As an adult, looking back on their childhood Frankie remembered knowing something was different about them, but not understanding what that difference meant. Though Frankie could pass as a man, they didn't like being called a man. Lamenting their lack of sexual interest in and even aversion toward men, they said, "I tried as hard as any woman on earth to be a woman." They thought maybe they just "hadn't been with the right man." Expressing their desire for women, they recalled, "I can't remember when I wasn't interested in women."[40] Frankie knew they were "homosexual," having encountered others in their work in show business. "Girls seemed to fall for me. . . . I never was what you call a big flirt."[41]

Frankie was raised Baptist but converted to Catholicism after dating a Catholic girl. They went to church every Sunday, stating, "I don't think God would have made me queer if it wasn't right."[42] They stressed the importance of helping children, the elderly, and the poor. They were generous with their money; "I never pass a person on the street who is begging. If it's my last penny I'll give it to him."[43]

Frankie had always wanted to fulfill their father's wishes for them to be a doctor. Their sisters were married to doctors and lawyers. Frankie's mother didn't understand them; she blamed Frankie's masculine ap-

pearance on their career. "Although I know I'm queer I don't like to be reminded of it,"[44] Frankie lamented.

At the time of their participation in the study Frankie was a popular performer on New York City's vaudeville circuit. They never knew what they were going to do before walking out onto the stage: "I never read from a script and I've never been a flop."[45] Their performances were improvisational combinations of slapstick comedy, music, singing, and male impersonation. Frankie had been on the stage since before they were twelve years old. They loved being able to support themselves and make their own living. At the time of their interview, they wanted to quit show business and move back to the quiet of the mountains where they were born.

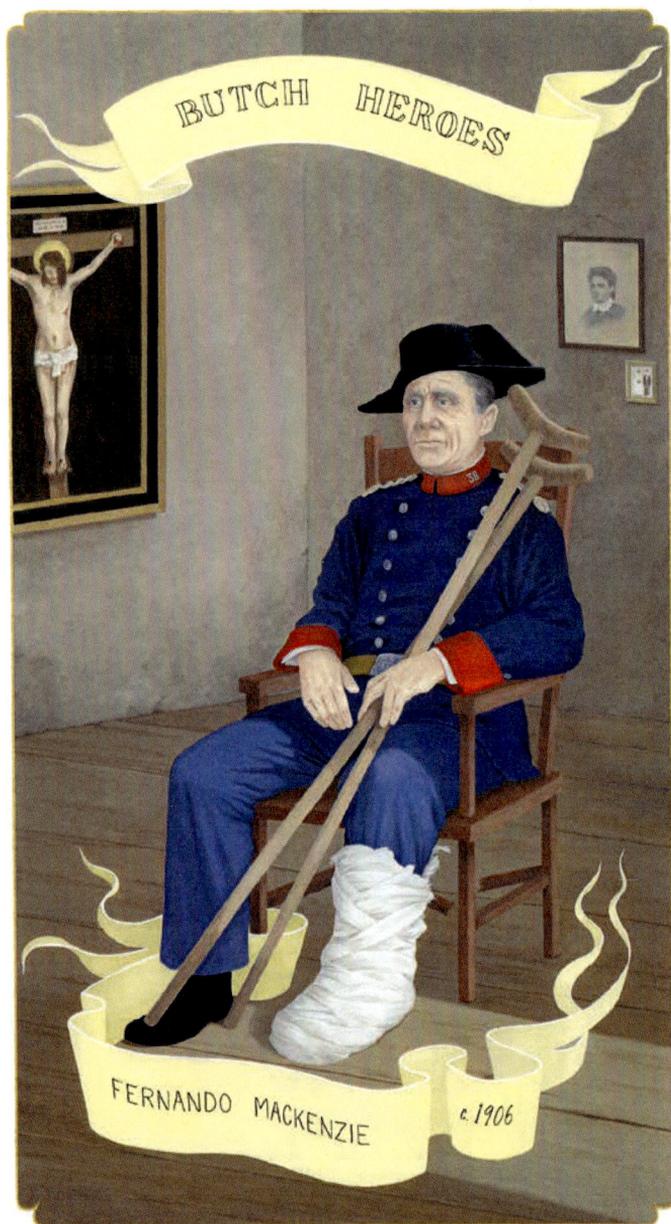

Fernando Mackenzie c. 1906 Spain, gouache on paper, 11 × 7 inches, 2022.

Fernando Mackenzie

Fernando was born in Paris around 1836 to a British father and a Spanish mother. After serving in the French military, he moved to Spain at the age of thirty-five and joined the police force in Madrid. He married and adopted his wife's son as his own.

The family moved to Seville, where Fernando served on the police force and worked as a cook and orderly in the governor's palace. He served seven successive governors, only losing his position after a fire destroyed the governor's palace.

When his wife died, he spent everything he had on her funeral. Two years later he was involved in a street accident that badly fractured his leg and left him in the hospital. The hospital stay resulted in his exposure and subsequent discharge from the police force without his pension.

A newspaper account from 1906 describes Fernando as in dire straits with rent coming due, sitting in his "miserable room" and turning to a large image of Christ as his only remaining resource.[46]

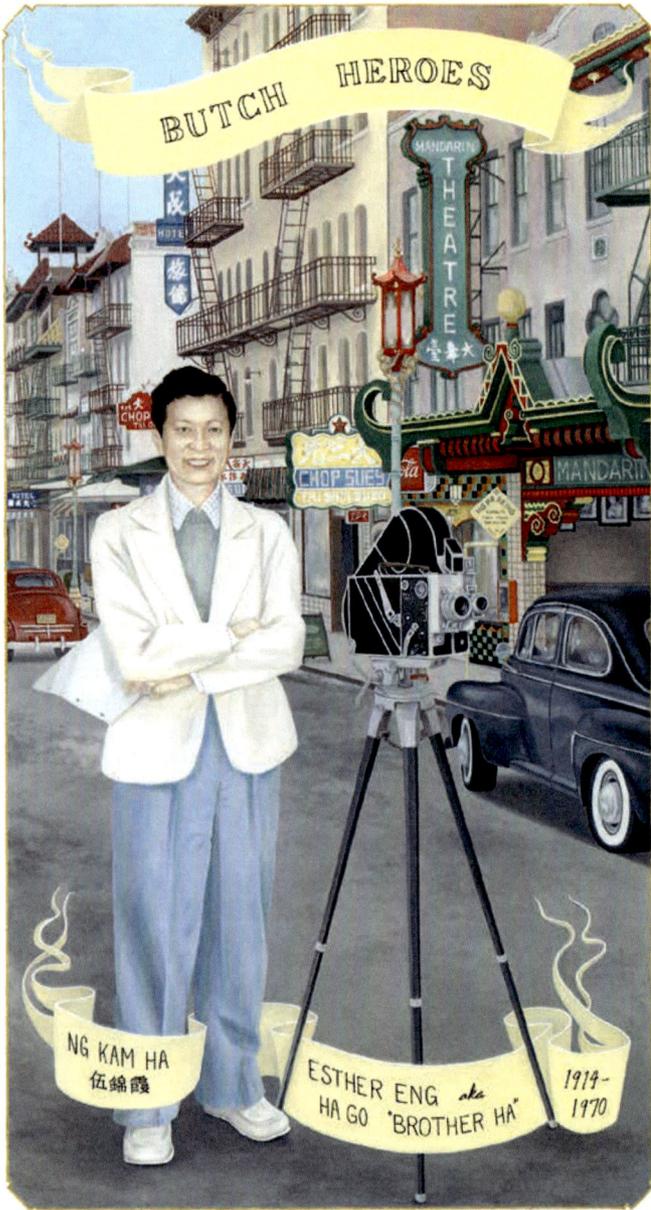

Esther Eng aka Brother Ha 1914–1970 United States, gouache on paper,
11 × 7 inches, 2022.

Esther Eng aka Brother Ha

At the time of her[47] death at age fifty-five in New York City, Esther Eng was most notable for several successful restaurants she owned in Chinatown, including Esther Eng's on Pell Street. All but forgotten was the fact that Esther was also one of the most important filmmakers in Chinese cinema.

Known as Brother Ha, Big Brother, or Uncle Ha to friends, Esther was born Ng Kam-ha in 1914. Like her parents, Esther was raised in San Francisco. Her grandparents had emigrated from Toi Shan County in China's Guangdong Province. Esther grew up with nine siblings at 1010 Washington Street.

At an early age Esther took an interest in theater, specifically the Cantonese opera that was popular at the time. The Mandarin Theatre, which was a short walk from Esther's home, brought in stars from southern China and Hong Kong to perform. Esther worked in the box office in her teens, and many of the performers became family friends of the Ngs.

In 1935, at the age of twenty-one, Esther convinced her father and his business associates to finance the film *Sum Hun (Heartaches)*, and they created their own production company, Cathay Pictures Ltd. It was headquartered at their home, and Esther opened an office in Hollywood. At around the same time Esther chose the professional name Eng, adding an E to Ng to make it easier for Americans to pronounce, and to avoid any confusion. ("N.G." could suggest "No Good" in film parlance.)[48]

Sum Hun was released in the United States and Hong Kong and starred Wai Kim-Fong, a famous Chinese opera star and a close friend of Esther's from the Mandarin Theatre. The film, co-produced by Esther, became known as the "first Cantonese singing-talking picture made in Hollywood." In 1936, Esther traveled with Wai Kim-Fong to Hong Kong for the film's premiere. The film's themes of national defense, patriotism, self-sacrifice, and gender equality were pertinent to audiences on the verge of the second Sino-Japanese war. Despite the brewing conflict with Japan, Esther remained in Hong Kong. In 1937, she opened a new production company, Gwong Ngai (Glorious Art), and at the age of twenty-two, with no prior experience, directed her first feature film *National Heroine*. Also starring Wai, the film centered on a woman who

joins the Chinese military, becomes a fighter pilot, and defends the motherland. The film was a huge success, earning Esther a Certificate of Merit from the Kwangtung Federation of Women's Rights and garnering praise for "honoring Chinese Womanhood." The publicity around *Sum Hun* and *National Heroine* meant Esther was frequently in the press. She was portrayed as a pioneer of Chinese film, "China's first woman director," a national patriot and even a fashion icon for her "boyish bob" and sporty looks. Esther always wore tailored suits.[49]

Following the success of *National Heroine*, Esther was in high demand. She was asked to make *10,000 Lovers* (1938) and agreed, but on the condition that Wai Kim-Fong was cast as the star. Soon after came *Jealousy* (1938), *Husband and Wife for One Night (A Night of Romance, a Lifetime of Regret)* (1938), and *It's a Woman's World (The Thirty-Six Amazons)* (1939). *It's a Woman's World* was the first film to feature an all-female cast and starred women from varying social positions. Throughout all this production Esther's health deteriorated, and her relationship with Wai became estranged. Esther never hid her romantic relationships. The press often referred to her female partners as her "bosom friends." However, an entertainment reporter for the *Sing Tao Daily* wrote in 1938, "We used to call Fong Esther's 'bosom friend,' but this is not quite right. Lover? Have you ever heard anything stranger? But I'm not lying. Wai and Esther were living proof that 'same-sex love' exists in this world."[50]

By October 1939, the Japanese occupation of Hong Kong and the onset of World War II led Esther to follow her family's wishes and move back to San Francisco. She had several projects in development but had to leave them all behind. Upon her return, Esther planned to focus on film distribution through her father's company but found herself directing again, this time *Golden Gate Girl*, released in 1941 with Grandview Pictures. The film was well received, but much of the acclaim went to the male screenwriter and lead actor Moon Kwan. With one exception in a *Variety* article from May 28, 1941, in which Esther is correctly credited as the director (and Moon Kwan as the screenwriter), Esther's name was absent in press coverage of the film. In a *San Francisco Chronicle* article from June 8, 1941, the "producer, director and star of the film" are interviewed, and Esther is never mentioned. Kwan even claimed full credit for the film in his memoirs.[51]

After Esther's father died, she took over the film import and distribution business, frequently traveling between the United States, China, Cuba, and Peru. In 1947, she was asked to direct *The Blue Jade* (*Lady from the Blue Lagoon*) starring the opera singer Sie Fei Fei, also known as Fe Fe Lee. Fe Fe would go on to star in two more of Esther's films, and the two formed an enduring relationship. In 1948, Esther set up her own company, Silver Light, and produced *Back Street* (1948) and *Mad Fire, Mad Love* (1949) in quick succession. Esther wrote to her friend Cheung Jok-hong, a publisher in Hong Kong, about how busy she was traveling for the business and shooting films.[52] With the end of the Chinese Civil War many of the Cantonese opera and film actors returned to China and Hong Kong, which left a major talent shortage in the United States. It was at this point that Esther and Fe Fe moved to New York City. Though Esther stopped making films at this time, she brought many films to New York, opened the Central Theater, and continued her distribution business.

Together with Fe Fe and a few business partners, Esther opened Bo Bo, the first of her restaurants, in New York's Chinatown. Bo Bo was small and served mainly Chinese dishes. At first it was a gathering place for visitors and Chinese performers who could not or did not want to return to newly communist China. It provided a welcome and safe space for them to learn English, get help with documentation, and find employment. People came to Bo Bo to meet Esther, and she took care of them—performers, elders, new immigrants, she made sure they had food, money, and a place to stay. Her friends described her as warmhearted, charismatic, charming, and always smiling. Bo Bo's popularity grew, frequented by Chinese film stars and staffed by beautiful actresses; it was the place to be. Craig Claiborne, the *New York Times* restaurant critic, wrote, "The only trouble with Bo Bo's is its extreme popularity ... at times it is next to impossible to obtain a table. However, the fare is worth waiting for."[53]

With the success of Bo Bo, Esther, Fe Fe, and their business partners soon opened four more restaurants, all in New York's Chinatown. Though she was now in the restaurant business, Esther was never far from the entertainment world. She was still distributing films, and her theater screened Cantonese-language films and occasionally hosted Cantonese opera troupes. Her restaurants were staffed and frequented

by performers. In 1962, she directed exterior scenes for what would be her final film, *Murder in New York Chinatown*. Sadly, all of the ten films Esther directed were lost, with the exception of a few exterior scenes from *Murder in New York Chinatown* and partial footage from *Golden Gate Girl* on VHS tape.

An article in the *New York Times* once described her as a "five-foot-tall dynamo."[54] Film critic and historian Law Kar noted, "If Eng had worked in the film industry today, she could have easily been seen as a champion of transnational filmmaking, feminist filmmaking, or antiwar filmmaking."[55] In January 1970, Esther died of cancer at Lennox Hill Hospital. Her friends kept her restaurants going for many years after her death. Her obituaries in the *New York Times* and *Variety* highlight her as a filmmaker, restaurateur, and proponent of Chinese culture.

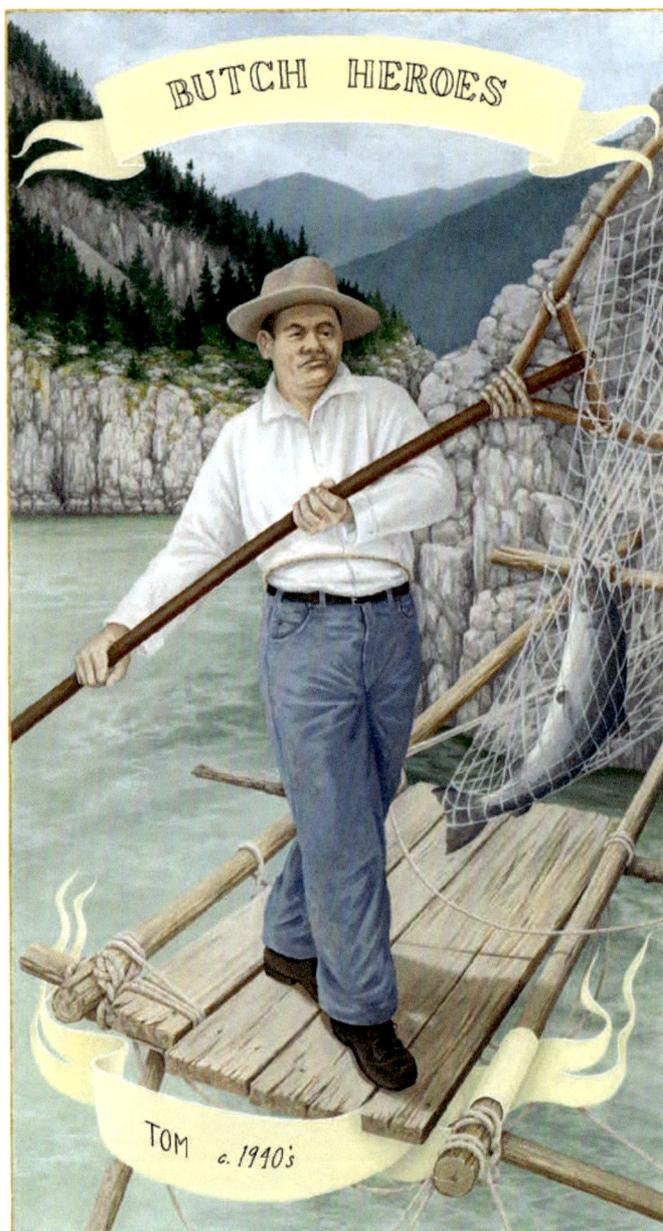

Tom c. 1940's Stó:lō, gouache on paper, 11 × 7 inches, 2022.

Tom

In 1949, Wilson Duff, a Canadian archaeologist, cultural anthropologist, and museum curator, began fieldwork for *The Upper Stalo Indians of the Fraser Valley, British Columbia*. One of Duff's informants was a resident of the Fraser Valley, a Tait man by the name of Edmond Lorenzetto.

Lorenzetto recalled "a woman at Yale [a nearby town] who lived the part of a man. She was called siɛ́ Tom, which he translated as 'a woman called Tom.'"[56] Or in another recollection, "'a woman who called herself Tom.' From Yale. He had a wife. She had a wife, but she was supposed to be a man. Wore men's clothes and went around as a man. He and wife got along okay. A good hunter and fisherman. Wasn't skwelem [Indian doctor], but was Indian dancer. Seemed to live a pretty normal life. Had no family."[57]

Though Lorenzetto described Tom as having no family, which Duff then translated as having had no children, he gave the impression that Tom and his wife, their marriage, and the life that they made together was accepted among their community.

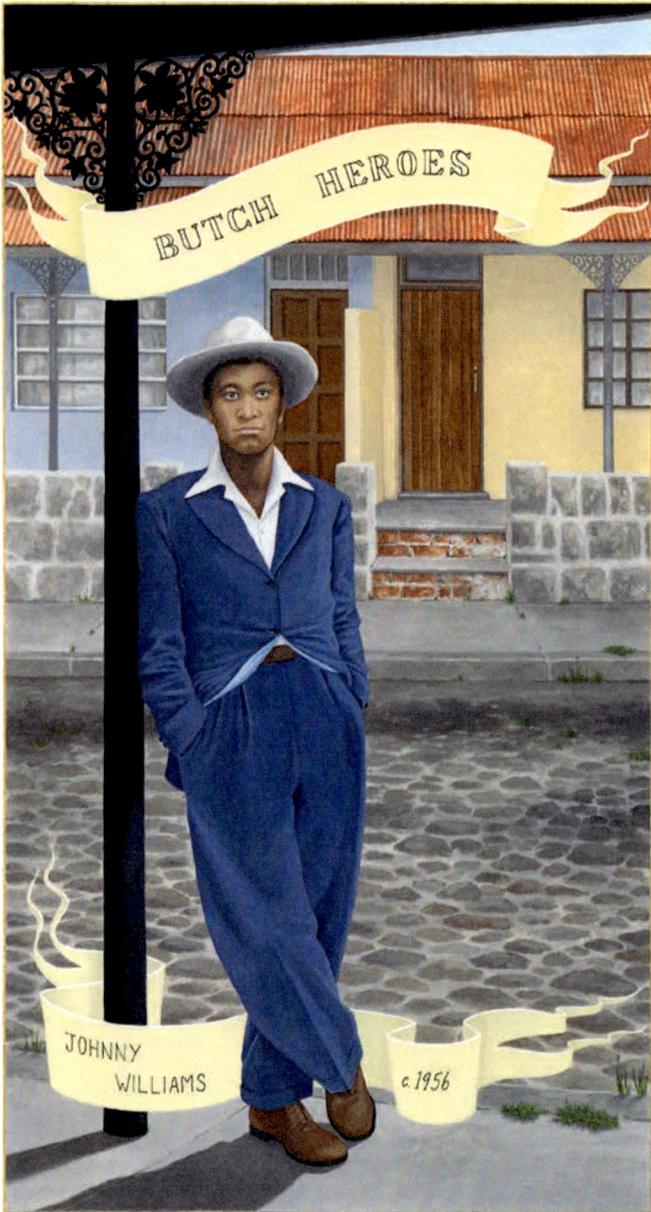

Johnny Williams c. 1956 South Africa, gouache on paper, 11 × 7 inches, 2022.

Johnny Williams

In 1955 Johnny Williams[58] shared his story with the *Golden City Post*, a South African newspaper, complete with a medical certificate stating that while he "has all the physical attributes of a woman, 'she shows mentally, a marked tendency to be identified with males, even to the extent of having girl friends.'"[59]

Williams was born around 1930 in Wynberg, Cape Town. From an early age he was in trouble for stealing, skipping school, drinking, and smoking. He hung out with the boys playing marbles, cricket, and football. The girls would call him "Gala man" and tomboy. After skipping choir practice and being found drunk, he was sent to a reformatory two hundred miles outside of Cape Town. For three months he worked on a farm, taking care of the farmer's children and doing work in the kitchen. His workload was not difficult, but he was lonely and bored. After three months he snuck out at night and followed the railway back to Wynberg. He wrote to his mother in an attempt to cover for himself, telling her that the farmer had come to town. But his mother suspected something was amiss and he was soon arrested. Arrangements were made to send him to another farm near Caledon.

When the farmer from Caledon came to pick up Williams at the station, he was wearing khaki shorts, a man's shirt, and his hair was cut short. Rather than working in the kitchen this time, Williams worked in the fields with the men and enjoyed the hard work: "No man could show me up because I kept up with them no matter how tough the work was."[60] He spent thirteen months on the farm, and though the farmer treated him well, and he was happy that the men did not suspect his sex, he was lonely again and missed the excitement of Cape Town. He arranged an escape with a friend who was a lorry driver in Caledon. However, upon arriving home in Wynberg his mother again reported him, and he was sent to the Kimberly Home for Girls.

There he spent four months sewing, doing "fancy work," and cleaning. At the age of fourteen he was sent to another girls' reformatory. Shortly after arriving and being issued a uniform, he was approached: "a longtimer, Doris X, came up to me and said, 'You'll be my girl friend.' I answered back very quickly: 'I am a man myself, so you'll have to forget

about it.' I then told her that I was an old jail-bird, and then they agreed
to let me be a 'man'. The few of us who were 'men' sat at table number
one, and we were the big shots of the place. The girls all respected us."[61]
Williams met a girl there named Irene who worked in the kitchen. They
were together for the five years that he was at the reformatory. When
King George VI visited South Africa in 1947, special remissions were
handed out and Williams received a pardon. He was put on a train to
Cape Town and returned to Wynberg.

Upon returning home he found a job at a shirt factory. He met a man
named Arthur; they were both in the Flying Tigers, a neighborhood
gang, and hung around the same corner. They hit it off. "We were to-
gether for over six months, but although I was very fond of him, things
just didn't click."[62] Williams broke it off with Arthur. "On the same day
I decided that I would change over completely and become a man. This
is what I had planned out in the reformatory. I left the factory, took my
savings out of the post office, and bought myself a shirt and a pair of
slacks. After that I went to a tailor and had a special suit made for myself.
I like a long cut coat, two tickey pockets, two back pockets, six belt hoops
and a 24 bottom."[63] Williams quit the Flying Tigers and joined the 44
Boys. They hung out on the corner smoking, drinking, gambling, and
fighting with other gangs. Williams liked to fight and had a particular
method that involved the use of a belt and buckle. Occasionally he was
subject to insults from rival gang members, taunting him about his gen-
der, but he could hold his own with ferocity and was quick to retaliate.

Williams earned money doing odd jobs. He worked as a caddy at a
golf club, hawked vegetables, or did handyman work, building walls
and doing repairs or gardening. These jobs were few and far between,
so he moved to Hout Bay and worked as a fisherman. Finally, he found
a job on a trawler and was at sea for three weeks. The work was hard.
He got blisters from the ropes and cuts from the crawfish, but he was
"ready for anything at any time." Things were going well on the trawlers
until Williams borrowed a nice blue suit from one of the crew with the
intention of returning it the next day. Unfortunately, the suit's owner
reported it as theft. Williams's grandfather told the police that he didn't
know a Johnny Williams and that Williams was a woman. The police
didn't believe it and had Williams examined. He was then ordered to

appear in court in a dress. He was sentenced to one month, suspended for two years.

Williams had a few relationships with women. He was always worried that they would leave when they found out his sex; a few did. He was afraid that the publication of his story in the *Golden City Post* would cost him his current relationship. In 1956, at the time of another account in *Drum*, a South African magazine, he was happily with a woman he had met at a party. He had asked her to dance, and even after finding out his sex they were still together. Despite this, he was always anxious: "What the end is going to be, I don't know. There is no hope of marriage for us, and the raising of a family which I yearn for. We will have to spend the rest of our lives living like this, unless God is merciful and . . . lets me become a whole man." He expressed multiple times throughout both accounts of his life that he wished to be a man. His closing thoughts in the *Golden City Post* were, "I also want you to know that when the first fruits of the season come to town I make wish before I eat them. My wish is that God must make me a man. It is the only thing I want most in the world." And in *Drum*, "My earnest prayer each night is that God would be merciful to me and change me completely into a man. If it could be done by any operation, I would gladly risk it as no pain could be too severe if it meant the fulfilment of my desire."[64]

S.E. FLEENOR IN CONVERSATION WITH RIA BRODELL

At the time of preparing for this conversation, anti-trans and -queer legislation, rhetoric, and violence are surging. We are quite literally fighting for our lives—particularly our Black, Brown, and Indigenous siblings, particularly transgender children—and we have to ask ourselves: Why do we continue to make art? What does a painting or a story mean in the face of abuse, discrimination, and hatred?

It's hard not to feel alone, like we're the first generation of queer and trans people fighting for our rights and lives. That feeling of isolation is not accidental. It's why far right extremists and centrists ban and burn our books. It's why they legislate us to the margins. They want us to feel alone—they want us to feel hopeless and helpless.

Just when I felt my most hopeless and helpless, I found *Butch Heroes*, and in the process found myself in the pages of history. I was starving for connection, thirsting for some evidence that I was not alone. I found comfort in the stories of people like me who rubbed others wrong just for being themselves—people who didn't *fit*, weren't *legible*, were considered *profane*. *Butch Heroes* changed something in me, and I knew I had to learn more about the project.

Ria Brodell answered all my burning questions when they were a guest on *Bitches on Comics*, the podcast I co-host where we interview LGBTQ+ folks and women comic, fiction, and pop culture creators and critics. While *Butch Heroes* might not seem an obvious match for our podcast, we relish the eclectic, and, more importantly, *Butch Heroes* embodies what we most ardently hunger for: compassionate storytelling and visual art about trans and queer people.

When Ria invited me back to ask all my burning questions about the next iteration, I jumped at the chance. Another book? New paintings? New stories? Oh, we definitely need to ask new questions . . . and so here we are!

S.E.: Since *Butch Heroes* first started in 2010, a lot has changed in the world, much of which directly or indirectly impacts this project. Whether we're talking about newly accessible archival research and dedicated spaces for sharing trans and queer stories or growing anti-trans and -queer antagonism, discrimination, and violence, the cultural shifts taking place are undeniable and touch us all in one way or another. What stands out to you most when you think about how these changes have impacted the project over its life?

RB: One of the biggest changes is in available resources. There are whole new archives, books, academic research, and papers devoted solely to trans and gender-variant lives and history. There are dedicated social media accounts for sharing knowledge and connecting with folks within the LGBTQ+ community. It's hard to believe, but sites like Facebook, Instagram, and Twitter (X) didn't exist in their current forms when I started this project. Of course, with that greater accessibility has come greater *visibility*, for better or worse.

Butch Heroes exists as it is because of what I was trying to achieve on a personal level, to satisfy my curiosity about queer history. I had no knowledge of our history, aside from relatively recent pop cultural figures, the Lavender Scare, the AIDS crisis…but I knew nothing about life before the twentieth century. We aren't taught about our history; we have to seek it out. And any reference to queer lives when I was growing up was either tragic or a punchline. When I started my research and began finding people I wanted to paint, I felt this urge to *prove* that we've always existed. So many of the books I found at the start of the project or read as a young adult were coded or our lives were presented in a speculative way—as if we didn't have our own queer history. I was tired of that. And I didn't want this project to fall into that realm of speculation, which is why I include all of my sources. I really focused on finding that "proof" for each individual that I included in the series.

As the project progressed, visibility increased, and I no longer felt the need to prove our existence. I know I belong here and that we have existed throughout time and I don't feel the need to prove that to anyone anymore. It even began to feel insulting in a way to have to *prove* our lives. Of course, LGBTQ+ people have existed, survived, and thrived all over the world. This shouldn't be in doubt.

With the increase in anti-trans rhetoric and violence over the last few years it became much harder to do the research, not physically but mentally and emotionally. At the beginning of the project, I think I was hopeful. I was seeing progress culturally—it was minor, but it was there. There was a contrast with what I was finding in the archives, not only in the language used for queer folks, but also in our treatment. I could say, "Look how far things have come!" But now, for the final paintings, the vitriol and hate I was reading in historical newspapers was eerily similar. There was really no difference from today. That was striking, and it was harder for me to spend my days in those archives. This persistence of violence and harmful rhetoric is why this project and other projects like it are still important.

S.E.: Between the publication of *Butch Heroes* and now, you reflected on what criteria you used to determine who to profile for the project, as you've already noted. Originally, to "prove" the existence of the people you profile, historical figures needed to have a documented name, dates, and multiple sources confirming that information; and to "prove" queerness, they had to have a masculine appearance and documented relationships with women. With this book, some of those criteria have changed, namely, you no longer require name and relationship status. Why did it feel necessary to broaden who was included in the project, and what have you learned from doing so?

RB: From the beginning I wanted to connect with the people I was choosing through my own experience. I always felt that it would have more resonance, because I would be able to understand at least to a small extent what they were going through. Hence the criteria. The names and dates were there to reinforce the facts. But I was finding folks whose stories were very interesting, and who I wanted to include but who didn't meet the "criteria"—perhaps there was no name written down or no relationships mentioned. I wanted to share their stories, too. These stories were still clearly true and backed up by factual sources. I learned that a name not included could have been negligence, but it could also have been tied to racism or sexism. It then became even more important to include them.

In terms of relationship status, I began to realize by looking at my own life over the course of the project that my relationships have changed over time—and those relationships have not impacted my queerness or my transness. I am who I am regardless of my relationship status. And relationships can take so many different forms!

This broader scope allowed me to include the stories of Joe Monahan, Names Unrecorded (Iñupiat), and Papa and his child.

S.E.: Defining the term "butch" for the sake of this project has been its own whole philosophical and introspective process—one that is wholly necessary to all queer and transgender projects in my opinion. LGBTQ+ people have invented, reclaimed, borrowed, and evolved words to describe ourselves and our communities for as long as we have existed. And that means we don't always agree on what different terms mean. Personally, I don't consider this to be a negative thing. I'm a firm believer that all language is metaphor, an imprecise expression of something truly ineffable, but that we find meaning in the effort of communicating. In your introduction, you discuss how you chose and define the term "butch" for this purpose, and I'm curious: Have you found it to be a useful term for communication? What have been the limitations of the term?

RB: I wholeheartedly agree with your assessment. A lot of how we express ourselves and exist as queer people defies definition through language. Further, one's choice of terminology is so personal. I ended up landing on the term "butch" because of both its specificity and expansiveness as well as its ties to the queer community. I remember writing down its definition: "notably or deliberately masculine in appearance or manner." I also remember reading somewhere early in the beginning of the project that some folks were using it to define a gender of its own, and I loved that.

I thought it would be a straightforward way to convey masculinity regardless of gender identity. In my experience many people used "butch," not just lesbian women. But the biggest difficulty with the term has come from within our own community. Because of its use in the lesbian community, the title sets a certain expectation for some, and their reactions have, at times, been transphobic. One of the reasons I chose

the term is because of the breadth of its meaning. To use and define the word "butch" in such a limited way, or even to dictate who can and can't use it—*this* was a big disappointment to me, to put it mildly, and something that still frustrates me.

S.E.: Historical projects like *Butch Heroes* require a lot of research and reading of historical accounts, which you've already mentioned. By and large, gender-variant, trans, and queer people do not appear favorably in historical records. The primary sources for this research, then, often come from newspaper reporting, police records, and other "official" documentation that contain explicit and implicit biases against the people you researched. Using these sources has required you to wade through racism, homophobia, transphobia, sexism, and other forms of xenophobia, as well as rampant censorship and obfuscation. How did you grapple with these sources? How did you learn to read between the lines of the oppressor to write the story of the oppressed?

RB: Yes, the sources can range from humorous to infuriating quite frequently. In all cases I try to imagine the scenario from the point of view of the subject. And I try to find *their* voice to help me get a sense of how they were navigating their life, or the particular experience. But unfortunately, that's not always possible. And, even if I do find it, I have to be careful. Newspapers were trying to sell copies. They embellished, sensationalized, and even sometimes fabricated whole stories. Editors and others were trying to make sense of lives they often didn't understand. If I'm looking through newspaper accounts, I'm trying to get as close to the local source as possible, when the event happened, because the further it gets from that point in time the more it gets obscured. It's very similar to the game of telephone.[65]

When it comes to other sources, like ethnographic reports or scientific journals, I have to remember the time period in which these reports are written and who is writing them. I am reading their biases. They are written by predominantly white, cisgender, heterosexual, Christian men with a very narrow view of the world.

S.E.: Reading the stories in *Butch Heroes* always feels to me like a spiritual experience, or at least what I think spiritual experiences must be like! I

never know when a profile will make me smile or make me weep, but I can count on them to connect me to the lineage of trans and queer folks throughout history and the world. We don't have time to go through every profile in this conversation, but there are a few I'd love to dive into a bit deeper. In your introduction, you noted that Names Unrecorded aka Papa's profile gave you an opportunity to represent parenthood, which you hadn't depicted before. Why was it important to depict trans parenting in this volume? What are we missing if we don't include trans parents in our conversations about trans identity?

RB: I was so excited to find Papa in the newspaper archives. It's rare to find mentions of children. Kathleen and her partner adopted a baby. And there have been others, like Johnny, who expressed their desire for family and children.

Papa's story piqued my interest and my imagination immediately. I really wish I had been able to find more of their story, but despite the limitations of the sources I felt it was important to represent them. Their story not only adds to the diversity of lives I'm trying to depict because he was a parent, but it also connects to our present-day lives in a different way. I am not a parent. For much of my life I thought that could never be an option for me. There is so much vitriolic rhetoric around queer folks having children, or queer folks "indoctrinating" children. Not to mention the homophobic and transphobic systems that make it much harder for queer folks to form families and have children. Again, it's dehumanizing. But so many of my friends and people in my community are parents or have children in their lives. My niblings bring so much joy to my life! So I thought it was important to show and affirm our humanity through that aspect within our history as well.

S.E.: You've shared before that one of your favorite aspects of this project is the detail that goes into each portrait in terms of clothing, environment, buildings, etc. Finding these historically accurate, intimate aspects of the lives of those you profile has required some hands-on research on your part. In the introduction to this volume, you mention Esther Eng aka Brother Ha and how you contacted the former owners of the theater depicted in her portrait so you could represent the facade accurately. Rendering trans stories in such vivid, well-researched detail

isn't just good art—it's an act of reclaiming our lives and our histories, a way of saying the nitty-gritty details of our lives matter. What was it like recovering, in a sense, the details of a person's life? Of course, given the marginality of those you've portrayed, many of the details have been erased. How did you decide when to fill in the gaps with a portrait?

RB: The details surrounding a person's life, even something as mundane as the wall color of a facade, can help to give us a full visual picture of what their lifetime looked like. The closer I can get to accurate details—to really pinpoint an exact location and time period—the better. For me it makes the image feel more real. I also love including aspects that bring their day-to-day into focus, like dirt on their pants, or a napping cat or the tools of their trade lying around.

The majority of the people I depict lived before the advent of photography, so my resources often consist of written descriptions for their likeness, or on rare occasions a painting of them. I always have to work from multiple sources to create the image. Esther Eng's portrait is set around the 1940s in San Francisco's Chinatown, which really wasn't that long ago compared to some of the other portraits. In addition to the theater facade, I was looking at car models, California license plates, street signage, lampposts, fire escapes, etc. Thankfully with this portrait I had a lot of resources to look to for those details. I consulted groups devoted to the history of San Francisco's theaters. I was able to use photographs from Esther's life, as well as a documentary and multiple books devoted to her life. I found sets of Kodachrome 35mm color slides on eBay to help with street scene details. And the manual for Esther's camera, the Ciné-Kodak Special, was a fun find!

Each portrait is different when it comes to the resources available, and sometimes that can influence my decision on painting one person rather than another. In addition to their life story, I get excited by the research involved in a particular place, or their occupation. For Esther Eng's portrait, I was excited by her story and the challenge of painting San Francisco's Chinatown.

S.E.: The stories in *Butch Heroes* are often filled with difficulty, pain, and discrimination, which maybe is to be expected given both historical and modern-day realities for nonbinary, trans, and gender-nonconforming

people. That's why the story of Gregoria Piedra aka la Macho stands out to me. That's not to say la Macho didn't face those difficulties—they suffered incarceration and persecution. However, la Macho's story carries a certain mischievousness and playfulness. In the face of exclusion, they were defiant to the point of eluding definition and flouted convention. What can we learn from la Macho about resilience and playful defiance?

RB: I love la Macho's story! In reading about la Macho, it seems to me that they lived their life the way they wanted to live it despite societal pressures, multiple arrests, and prosecutions. La Macho was seen as unclassifiable and caused confusion among the authorities at the time. They used humor and mischief to point out the limitations in their society and the hypocrisy of the Catholic church. They were said to be indifferent to the multiple punishments inflicted upon them, and through it all they still kept their devotion to their faith. Like many other people in the series, la Macho consistently broke their society's rules. These stories remind us that being authentically yourself, playing outside of social norms, and not letting conventional expectations dictate how you live is super queer!

S.E.: *Butch Heroes* is clearly a historical and artistic endeavor—it's also a personal one. In the introduction, you discuss the painting *Self-Portrait as a Nun or Monk c. 1250* as a contemplation of what life might have been like if you'd been born in another century. That painting sparked your curiosity about trans, nonbinary, and queer people in history and how they lived, leading to what has become *Butch Heroes*. Now that you've reached the end of this project, you understand yourself better as a trans, nonbinary, queer person at this moment in history and have answered the bigger question of belonging you first asked yourself in that self-portrait. Seeing the tethers that connect you to the past and extend into the future has somewhat unexpectedly allowed you to discover a sense of peace in knowing that you are yourself in all your unique and shared attributes, and that's okay. I'd love to hear about how finding people to paint and profile who were like and unlike you impacted your journey of self-discovery, and what honoring that experience looks like to you in your everyday life.

RB: Ooh, great question. We've talked a lot about how important it is to have access to these stories, not only to prove that we've existed throughout history, but to give ourselves access to role models that we don't have in heteronormative society. Access to this representation has been extremely important for my own sense of self and formation of my identity. It's helped me develop more compassion and acceptance for myself. Gender has always been a struggle, not because I haven't known who I am, but because of the fear around how others—family, friends, strangers, even people within our own community—will perceive or react to me. I know I'm not alone in that sense, I know that this is an experience that many queer and trans folks have. The research for this project showed me our history of strength, struggle, and perseverance. It also showed me that queerness and transness come in many forms. I used to struggle a lot with "Am I trans enough?" "Do I fit in this box?" When I started to see myself in our history, it helped me realize that I do belong, there is no "right" or "wrong" way to be. I suppose that's the compassion and self-acceptance part, being able to acknowledge how far I've come, and learning that my path can be whatever it needs to be. It doesn't have to look a certain way or have a certain outcome.

S.E.: You've been working on *Butch Heroes* in some format or another for fifteen years, and with this publication the project is coming to an end. How did you know it was time to move on, will there be anything you miss from the creative process, and, finally, what will you carry forward from *Butch Heroes* into the rest of your art and life?

RB: Well, I think a few things happened. When Covid hit I was forced to pause, as we all were, and I had some realizations. I started to feel like I needed a change. I no longer liked spending so much time indoors. The physicality of the painting process started to wear on my body. And I knew I couldn't keep working in the same way. I'll miss the excitement of the research, searching for stories. And I'll miss the places that each painting took me from rural North Carolina to Cape Town, South Africa, each painting meant that I could learn about a new place and time period. Getting the books published has allowed me to connect with so many people I would have never met or interacted with otherwise.

It's been an amazing experience, and it feels complete. I accomplished what I set out to do, and now I'm ready for new adventures.

S.E.: At the beginning of our conversation, I posed the question of why we create art in the face of discrimination. To me, that answer is clear.

The archive—and projects like *Butch Heroes* that draw from it—give us an anchor to history, to the gender-variant, nonbinary, transgender, and queer people who created lives long before the words we use to describe them existed. We have *always* been here, and *Butch Heroes* stands like a clarion call rejecting the othering of transness and queerness. We were there and we are here now. *We* will never go away and we *will* create a better world.

And no matter how hard they try to erase us, no matter how badly they discriminate against and punish us, no matter how difficult they make our lives, no matter how many of us they kill, we will still be queer and trans, we will still be gender-nonconforming, gender-deviant, gender-expansive, gender-defying.

And like la Macho we will grin while we do it, freer than they could ever imagine.

Acknowledgments

Thank you to the writers, scholars, and archivists who make LGBTQIA history their life's work; without your tireless research and commitment this project would not exist.

Thank you to all those who have emailed me over the span of this project to offer me encouragement, corrections, or suggestions. I am so grateful to have had the opportunity to reach so many people throughout this process!

Butch Heroes might have ended prematurely if not for the support and guidance of Sarah Saydun and the encouragement of so many friends, Hannah, Eva Lundsager, Paul Ha, Brooke Stewart, and Ellen Caldwell. Ellen, thanks for giving me the opportunity to reach so many students. Every time I spoke with them about *Butch Heroes* I came away feeling rejuvenated and excited.

Thank you to my family, especially my siblings—Julie, Nick, and Chris—for always being there for me.

Thank you to Chris Vargas and S.E. Fleenor for your contributions. S.E., our Zoom conversations were truly a highlight throughout this process. And finally to the folks at the MIT Press, in particular Victoria Hindley for believing in the book so fiercely.

Notes

Introduction

1. Clare Sears, *Arresting Dress: Cross-Dressing, Law, and Fascination in Nineteenth-Century San Francisco*. (Durham, NC: Duke University Press, 2015), 94, citing Daphne Lei, "The Production and Consumption of Chinese Theatre in Nineteenth-Century California," *Theatre Research International* 28, no. 3 (2003): 289–302.

Agatha Dietschi aka Hans Kaiser

2. Helmut Puff, "The Sodomite's Clothes: Gift-Giving and Sexual Excess in Early Modern Germany and Switzerland," in *The Material Culture of Sex, Procreation, and Marriage in Premodern Europe*, ed. Anne McClanan and Karen Encarnación (New York: Palgrave, 2002), 253.

3. Helmut Puff, *Sodomy in Reformation Germany and Switzerland, 1400–1600* (Chicago: University of Chicago Press, 2003), 34.

4. Ibid.

Rosa Hidalgo and Andrea Ayala

5. Chad Thomas Black, "Prosecuting Female-Female Sex in Bourbon Quito," in *Sexuality and the Unnatural in Colonial Latin America*, ed. Zeb Tortorici (Berkeley: University of California Press, 2016), 130, http://www.jstor.org/stable/10.1525/j .ctt19b9jgt.11.

6. Ibid., 131.

7. Ibid., 134.

8. Ibid.

Gregoria Piedra aka la Macho

9. Ursula Camba Ludlow, "Gregoria la Macho y su 'inclinación a las mujeres': reflexiones en torno a la sexualidad marginal en Nueva España, 1796–1806," *Colonial Latin America Historical Review* 12, no. 4 (Fall 2003): 489–490.

10. In colonial Mexico the term pardo meant a person of mixed African, European, and Indigenous ancestry. In the colonial period, people considered pardo, like all nonwhites, were kept in a state of servitude, with no chance of gaining wealth or political power.

11. Ibid., 485.
12. Ibid., 492–493.

Johan "Jack" Jorgensen

13. Lucy Sarah Chesser, *Parting with My Sex: Cross-Dressing, Inversion and Sexuality in Australian Cultural Life* (Cocos (Keeling) Islands: Sydney University Press, 2008), 54.
14. Ibid., 192.
15. "Extraordinary Case of Personation," *Bendigo Advertiser* (Bendigo, Victoria), September 7, 1893, 3.
16. Ibid.

Sarah aka Samuel Pollard

17. "A Female Husband," *Woburn Journal* (Woburn, MA), June 8, 1878, 1.
18. Marie Coady, *Woburn: Hidden Tales of a Tannery Town* (Charleston, SC: History Press, 2008).
19. "Sarah Pollard, Esq.," *Idaho Statesman* (Boise, ID), June 1, 1878, 2.
20. "It Is Coming," *Daily Appeal* (Carson City, NV), May 21, 1879, 3.
21. *Indiana Progress* (Indiana, PA), June 20, 1878, 9.
22. Quote from the *Tuscarora Times-Review*, May 27, 1878, in Homer J. Thiel, "An 1877 Same-Sex Marriage in Nevada: An Episode in the Unconventional Life of Sarah Pollard," *American Ancestors* 12, no. 3 (Summer 2011): 42.
23. "A Unique Minnesota Girl," *Morning Democrat* (Davenport, IA), July 22, 1892.

Joe Monahan

24. Peter Boag, *Re-Dressing America's Frontier Pas* (Berkeley: University of California Press, 2011), 101.
25. Quote from the *Boise Evening Capital News*, January 13, 1904, in ibid., 97.
26. Quote from the *Buffalo Evening News*, January 11, 1904, in ibid., 102.
27. Ibid., 96.
28. I tell their stories in the first *Butch Heroes*. In the case of Sammy Williams, the press created the story of a young Norwegian girl named Ingeborge Weken whose fiancé abandoned her, forcing her to take up life in the lumber camps, while the *London Chronicle* sold the thirty-nine-year relationship of Mr. and Mrs. How as a story of two young girls spurned by their suitors who vowed never to take husbands, and instead flipped a halfpenny to determine who would be the husband and who would be the wife.

Names Unrecorded

29. William H. Dall, "Social Life among Our Aborigines," *American Naturalist* 12, no. 1 (January 1878): 5.
30. Ibid.
31. Ibid.

Names Unrecorded aka Papa

32. I do not know for certain if these two accounts from local North Carolina newspapers represent the same person because neither of them includes a name. I do know that individuals who did not conform to gender roles were often mentioned in the papers or, worse, arrested and fined multiple times. It is not improbable that "Papa" was arrested in 1877, when their child was three months old, and then again made the papers in 1879 for the same offense.

Georgie Phillips

33. "Women Who Wear Trousers," *Denver Times* (Denver, CO), July 13, 1889.

Kathleen

34. Kathleen M. is the pseudonym used in George W. Henry, *Sex Variants: A Study of Homosexual Patterns*, 2d ed., in one volume (New York: Paul B. Hoeber, 1948).
35. Henry, *Sex Variants*, 830.
36. Ibid., 837.
37. Ibid., 838.
38. Ibid.

Myrtle aka Frankie

39. George W. Henry, *Sex Variants: A Study of Homosexual Patterns*, 2d ed., in one volume (New York: Paul B. Hoeber, 1948), 780.
40. Ibid., 782.
41. Ibid., 783.
42. Ibid., 785.
43. Ibid.
44. Ibid., 784.
45. Ibid., 785.

Fernando Mackenzie

46. "Woman Policeman," *Columbia Herald* (Columbia, TN), November 23, 1906.

Esther Eng aka Brother Ha

47. It is possible that Esther would have used different pronouns if presented with today's options. In every account I found, colleagues, friends, and family used "she/her," sometimes in combination with "Brother" or "Uncle." I considered using "they," but I did not feel that I had sufficient information and therefore did not feel comfortable making that choice for Esther.
48. Kar Law, "In Search of Esther Eng: Border-Crossing Pioneer in Chinese-Language Filmmaking," in *Chinese Women's Cinema: Transnational Contexts*, ed. Lingzhen Wang (New York: Columbia University Press, 2011), 317.
49. As described in a documentary about Eng, *Golden Gate Girls/Golden Gate, Silver Light*, directed, produced, and screenplay by S. Louisa Wei (Hong Kong: Hong Kong Art Development Council and Blue Queen Cultural Communication Ltd., 2013), HDV, 90 minutes.
50. Ibid.

51. Kar Law and Frank Bren, "The Esther Eng Story," in *Hong Kong Cinema: A Cross Cultural View* (Lanham, MD: Scarecrow Press, 2004), 98.
52. *Golden Gate Girls*, dir. Wei.
53. "Esther Eng Owned Restaurants Here," *New York Times*, January 27, 1970.
54. Kathleen McLaughlin, "Industry Is Up as Tourism Falls Off: Clothes and Food Spur Chinatown Economy," *New York Times*, June 29, 1967.
55. Law, "In Search of Esther Eng," 313.

Tom

56. Wilson Duff, *The Upper Stalo Indians of the Fraser Valley, British Columbia* (Victoria: British Columbia Provincial Museum, Department of Education, 1952), 78.
57. Quote from Wilson Duff's Field Notes, summer 1950, in Jean C. Young, "Alternative Genders in the Coast Salish World: Paradox and Pattern" (thesis, University of British Columbia, 1999), 19. doi: http://dx.doi.org/10.14288/1.0089206.

Johnny Williams

58. I use the name Johnny Williams only, and "he/him" pronouns throughout this account (despite most sources doing otherwise). I do this because Johnny specifically stated his preferences. Dhianaraj Chetty, "Lesbian Gangster: The Gertie Williams Story," in *Defiant Desire*, ed. Mark Gevisser and Edwin Cameron (New York: Routledge, 1995), 131.
59. Ibid., 128.
60. Ibid., 130.
61. Ibid.
62. Ibid., 131.
63. Ibid.
64. Ibid., 133.

S.E. Fleenor in Conversation with Ria Brodell

65. Emily Skidmore talks about this phenomenon in her book *True Sex: The Lives of Trans Men at the Turn of the Twentieth Century* (New York: New York University Press, 2019).

Bibliography

Introduction

Sears, Clare. *Arresting Dress: Cross-Dressing, Law, and Fascination in Nineteenth-Century San Francisco*. Durham, NC: Duke University Press, 2015.

Agatha Dietschi aka Hans Kaiser

Puff, Helmut. "The Sodomite's Clothes: Gift-Giving and Sexual Excess in Early Modern Germany and Switzerland." In *The Material Culture of Sex, Procreation, and Marriage in Premodern Europe*, ed. Anne McClanan and Karen Encarnación, 251–272. New York: Palgrave, 2002.

Puff, Helmut. *Sodomy in Reformation Germany and Switzerland, 1400–1600*. Chicago: University of Chicago Press, 2003.

Simon-Muscheid, Katharina. "Geschlecht, Identität und soziale Rolle: Weiblicher Transvestismus vor Gericht, 15. / 16. Jahrhundert." *Schweizerische Gesellschaft für Wirtschafts- und Sozialgeschichte* 13 (1995): 45–57.

Rosa Hidalgo and Andrea Ayala

Archivo Nacional de Ecuador. "Causa criminal seguido de oficio contra Andrea Ayala, y Rosa Hidalgo (o Benalcázar), sindicado del pecado nefando." Serie Criminales, Caja 99, Expediente 3 (99.3), 2-xii-1782.

Black, Chad Thomas. "Prosecuting Female-Female Sex in Bourbon Quito." In *Sexuality and the Unnatural in Colonial Latin America*, ed. Zeb Tortorici, 120–140. Berkeley: University of California Press, 2016.

Gregoria Piedra aka la Macho

Archivo General de la Nación, Mexico City, Inquisición vol. 1349, exp. 28, fol. 337, fol. 344.

Carrera, Magali M. *Imagining Identity in New Spain: Race, Lineage, and the Colonial Body in Portraiture and Casta Paintings*. Austin: University of Texas Press, 2003.

Ludlow, Ursula Camba. "Gregoria la Macho y su 'inclinación a las mujeres': reflexiones en torno a la sexualidad marginal en Nueva España, 1796–1806." *Colonial Latin America Historical Review* 12, no. 4 (Fall 2003): 479–497.

Penyak, Lee. "Criminal Sexuality in Central Mexico 1750–1850." Ph.D. dissertation, University of Connecticut, 1993.

Johan "Jack" Jorgensen

Chesser, Lucy Sarah. *Parting with My Sex: Cross-Dressing, Inversion and Sexuality in Australian Cultural Life.* Cocos (Keeling) Islands: Sydney University Press, 2008.

"The Elmore Male Impersonation Case." *Bendigo Advertiser* (Bendigo, Victoria), September 13, 1893.

"The Elmore Romance." *Bendigo Independent* (Bendigo, Victoria), September 9, 1893.

"Extraordinary Case of Personation." *Bendigo Advertiser* (Bendigo, Victoria), September 7, 1893.

"Jack Jorgensen." *Coronado Mercury* (Coronado, CA), May 24, 1894.

Sarah aka Samuel Pollard

Basler, George, and Gerald R. Smith. *On the Seamy Side of the Street: Colorful Characters from Broome County's History.* Binghamton, NY: Broome County Historical Society, 2013.

Coady, Marie. *Woburn: Hidden Tales of a Tannery Town.* Charleston, SC: History Press, 2008.

"Condensed Telegrams." *Daily Appeal* (Carson City, NV), May 29, 1878.

"A Female Husband." *Woburn Journal* (Woburn, MA), June 8, 1878.

Indiana Progress (Indiana, PA), June 20, 1878.

"It Is Coming." *Daily Appeal* (Carson City, NV), May 21, 1879.

"Latest News." *Idaho Avalanche* (Silver City, ID), June 29, 1878.

"A Nevada Sensation." *Daily Alta California* (San Francisco, CA), May 31, 1878.

"Pollardana." *Daily Appeal* (Carson City, NV), April 26, 1879.

"Pollard as a Shoemaker." *New North West* (Deer Lodge, MT), July 5, 1878.

"The Pollard Sensation Again." *Daily Appeal* (Carson City, NV), May 22, 1878.

"Sarah Pollard, Esq." *Idaho Statesman* (Boise, ID), June 1, 1878.

Thiel, Homer J. "An 1877 Same-Sex Marriage in Nevada: An Episode in the Unconventional Life of Sarah Pollard." *American Ancestors* 12, no. 3 (Summer 2011): 40–43.

"A Unique Minnesota Girl." *Morning Democrat* (Davenport, IA), July 22, 1892.

Joe Monahan

Boag, Peter. "Go West Young Man, Go East Young Woman: Searching for the Trans in Western Gender History." *Western Historical Quarterly* 36, no. 4 (2005): 477–497.

Boag, Peter. *Re-Dressing America's Frontier Past*. Berkeley: University of California Press, 2011.

"Masqueraded Many Years as a Cowboy." *Buffalo Evening News* (Buffalo, NY), January 11, 1904.

Skidmore, Emily. *True Sex: The Lives of Trans Men at the Turn of the Twentieth Century*. New York: New York University Press, 2019.

Names Unrecorded

Dall, William H. "Social Life among Our Aborigines." *American Naturalist* 12, no. 1 (January 1878): 1–10.

Roscoe, Will. *Changing Ones: Third and Fourth Genders in Native North America*. New York: St. Martin's Press, 1998.

Names Unrecorded aka Papa

"A Child Who Calls Its Mother 'Papa.'" *The Times* (city unknown), October 2, 1879.

"A Strange Woman." *Tarborough Southerner* (Tarboro, NC), September 25, 1879.

Wilmington Morning Star (Wilmington, NC), March 24, 1877.

Georgie Phillips

Jameson, Elizabeth, and Susan H. Armitage, eds. *Writing the Range: Race, Class, and Culture in the Women's West*. Norman: University of Oklahoma Press, 1997.

"Women Who Wear Trousers." *Denver Times* (Denver, CO), July 13, 1889.

Kathleen

Henry, George W. *Sex Variants: A Study of Homosexual Patterns*. 2d ed. in one volume. New York: Paul B. Hoeber, 1948.

Myrtle aka Frankie

Henry, George W. *Sex Variants: A Study of Homosexual Patterns*. 2d ed. in one volume. New York: Paul B. Hoeber, 1948.

Terry, Jennifer. *An American Obsession: Science, Medicine, and Homosexuality in Modern Society*. Chicago: University of Chicago Press, 1999.

Fernando Mackenzie

Ellis, Havelock. *Studies in the Psychology of Sex: Sexual Inversion*. Philadelphia: F. A. Davis Company, 1915.

"Woman Policeman." *Columbia Herald* (Columbia, TN), November 23, 1906.

Zagria. "Fernando Mackenzie (1836–?) Policeman." *A Gender Variance Who's Who: Essays on Trans, Intersex, Cis and Other Persons and Topics from a Trans Perspective*. April 19, 2008. http://zagria.blogspot.com/2008/04/fernando-mackenzie-1836-policeman .html.

Esther Eng aka Brother Ha

Bren, Frank. "Electric Phantom—The Indomitable Esther Eng." *China Daily*, January 23, 2010. http://www.chinadaily.com.cn/hkedition/2010-01/23/content_9365379.htm.

"Esther Eng Owned Restaurants Here." *New York Times*, January 27, 1970.

Gadd, Christianne A. "Esther Eng: Filmmaker, Restaurateur, Gender Rebel." *Outhistory*, October 22, 2016. https://outhistory.org/exhibits/show/esther-eng/essay.

Golden Gate Girls/Golden Gate, Silver Light. Directed, produced, and screenplay by S. Louisa Wei. Hong Kong: Hong Kong Art Development Council and Blue Queen Cultural Communication Ltd., 2013.

Law, Kar. "In Search of Esther Eng: Border-Crossing Pioneer in Chinese-Language Filmmaking." In *Chinese Women's Cinema: Transnational Contexts*, ed. Lingzhen Wang, 313–329. New York: Columbia University Press, 2011.

Law, Kar, and Frank Bren. "The Esther Eng Story." In *Hong Kong Cinema: A Cross Cultural View*, 91–103. Lanham, MD: Scarecrow Press, 2004.

McLaughlin, Kathleen. "Industry Is Up as Tourism Falls Off: Clothes and Food Spur Chinatown Economy." *New York Times*, June 29, 1967.

Osman, Meg. "The Elegant Life of Esther Eng." *Forever a Pleasure*, May 26, 2021. https:// www.foreverapleasure.com/blog/esthereng.

Wei, S. Louisa. "Esther Eng." In *Women Film Pioneers Project*, ed. Jane Gaines, Radha Vatsal, and Monica Dall'Asta. New York: Columbia University Libraries, 2014. https:// doi.org/10.7916/d8-rhpq-0f69.

Tom

Duff, Wilson. *The Upper Stalo Indians of the Fraser Valley, British Columbia*. Victoria: British Columbia Provincial Museum, Department of Education, 1952.

Young, Jean C. "Alternative Genders in the Coast Salish World: Paradox and Pattern." Thesis, University of British Columbia, 1999. http://dx.doi.org/10.14288/1.0089206.

Johnny Williams

Chetty, Dhianaraj, ed. "Lesbian Gangster: The Gertie Williams Story." In *Defiant Desire*, ed. Edwin Cameron and Mark Gevisser, 128. New York: Routledge, 1995.

McCormick, T. L. "Dragging Up the Past: Investigating Historical Representations of Drag in South Africa." *Gender and Language* 12, no. 2 (2018):168–191. https://doi.org /10.1558/genl.25741.

Peach, Ricardo. "Chapter 2—Skeef: A Brief History of South African Queer Cinematic Cultures." In "Queer Cinema as a Fifth Cinema in South Africa and Australia," 88. PhD Thesis, University of Technology, Sydney, 2005.

Perkins, Cody. "Coloured Men, Moffies, and Meanings of Masculinity in South Africa, 1910–1960." Dissertation, University of Virginia, 2015. doi:10.18130/V3XG1W.

Scott, J., and L. Theron. "The Promise of Heteronormativity: Marriage as a Strategy for Respectability in South Africa." *Sexualities* 22, no. 3 (2019): 436–451. https://doi.org .ezproxy.library.tufts.edu/10.1177/1363460717713384.

Contributors

RIA BRODELL is an artist, educator, and author based in Boston. Brodell attended the School of the Art Institute of Chicago and received a BFA from Cornish College of the Arts in Seattle and an MFA from the School of the Museum of Fine Arts/Tufts University. Brodell has exhibited internationally and throughout the United States and is a recipient of an Artadia Award, a Massachusetts Cultural Council Artist Fellowship, and an SMFA Traveling Fellowship. Their work has appeared in *New York* magazine, *The Guardian*, *ARTNews*, the *Boston Globe*, and *New American Paintings*, among other publications.

S.E. FLEENOR is an essayist, culture critic, fiction writer, and editor. Their words appear in print and online at *The Independent*, *VICE*, *Electric Literature*, *them.us*, *Upworthy*, *Decoded Pride*, *Phasers on Stun!*, *Class Lives*, and many more. They teach writing workshops with Writer's Digest University, at public libraries, etc. and co-host the comics and pop culture podcast *Bitches on Comics*, as well as being a head writer for the narrative fiction podcast *Decoded Horror Channel*. They are a member of GALECA: the society of LGBTQ entertainment critics and graduated from Harvard University with a master's in theological studies, focusing on religion and gender and sexuality, as well as literature, TV, and film.

CHRIS E. VARGAS is a video maker and interdisciplinary artist. He earned his MFA from the Art Practice department at Berkeley in 2011. He is the Executive Director of MOTHA, the Museum of Transgender Hirstory & Art, a critical and conceptual arts and hirstory institution highlighting the contributions of trans art to the cultural and political landscape. His book, an extension of MOTHA, *Trans Hirstory in 99 Objects* (2023, coedited with Christina Linden and David Evans Frantz), brings together a wide-ranging selection of artworks and artifacts that highlight the underrecognized histories of trans, nonbinary, and gender-nonconforming communities.